Inventing Byzantine Iconoclasm

This page intentionally left blank

STUDIES IN EARLY MEDIEVAL HISTORY

Inventing Byzantine Iconoclasm

Leslie Brubaker

Bristol Classical Press

First published in 2012 by
Bristol Classical Press
an imprint of
Bloomsbury Academic
Bloomsbury Publishing Plc
50 Bedford Square
London WC1B 3DP, UK

Copyright © 2012 by Leslie Brubaker

All rights reserved. No part of this publication
may be reproduced, stored in a retrieval system, or
transmitted, in any form or by any means, electronic,
mechanical, photocopying, recording or otherwise,
without the prior permission of the publisher.

CIP records for this book are available from the
British Library and the Library of Congress

ISBN 978-1-85399-750-1

Typeset by Ray Davies
Printed and bound in Great Britain

www.bloomsburyacademic.com

Contents

List of illustrations	viii
Abbreviations	x
Preface and Acknowledgements	xv

1. Introduction: what is Byzantine iconoclasm? — 1
 Who were the Byzantines? — 1
 Terminology: icons, iconoclast, iconoclasm, iconomachy — 3
 Chronology: a brief sketch — 4
 The sources — 5
 Approach — 6

2. The background — 9
 Belief and practice — 9
 The Orthodox hierarchy — 9
 Intercession — 10
 The cult of saints and the cult of relics — 10
 Relics, images and icons — 11
 Images not-made-by-human-hands — 11
 Images made by human hands — 13
 The changing role of icons — 13
 The Persian war and the Islamic conquests — 15
 Why did the role of icons shift around the year 680? — 16
 Conclusions — 18

3. The beginnings of the image struggle — 22
 Constantine of Nakoleia, Thomas of Klaudioupolis and local reactions against religious images — 22
 The political backdrop: Leo III's rise and achievements — 24
 Leo's rise to power — 25
 Leo and the Arabs — 25
 Leo's reforms — 25
 Was Leo III an iconoclast? — 27

Contents

4. Constantine V, the 754 synod, and the imposition of an official anti-image policy ... 32
 The iconoclast synod of 754 ... 33
 The destruction – and construction – of images ... 35
 Artisanal production under Constantine V ... 39
 Byzantium and its neighbours ... 45
 The stabilisation of Byzantine frontiers ... 45
 Byzantium and the west ... 46
 The western response to the Council of 754 ... 46
 Constantine V and the monasteries: persecution or a response to treason? ... 47
 Conclusions ... 49

5. The iconophile intermission ... 56
 Leo IV (775-780) ... 57
 Rome and the Bulgars ... 58
 Eirene and Constantine VI (780-797), Nikaia II and the restoration of image veneration ... 59
 Papal and Frankish responses to the 787 Council ... 62
 The political background ... 62
 The response to Nikaia II ... 62
 Byzantine responses to the 787 Council ... 64
 Hagia Sophia in Thessaloniki ... 64
 Other imperial commissions ... 65
 Non-imperial commissions: the cross-in-square church plan ... 66
 Monastic reform and new technologies of writing ... 68
 The introduction of minuscule ... 69
 Cross-cultural exchange ... 70
 Icons and pilgrimage to Mount Sinai ... 70
 Silks and cross-cultural exchange ... 72
 Constantine VI and Eirene ... 77
 The 'moichian controversy' and the deposition of Constantine VI ... 78
 The empress Eirene (797-802) ... 79
 Nikephoros I (802-811) and Michael I Rangabe (811-813) ... 81

Contents

6. The iconoclasts return	90
Why was 'iconoclasm' revived?	90
Theophilos and the Arabs	93
Theophilos (829-842) as emperor	94
Hagia Sophia and the new balance of power between church and state	95
Theophilos as builder – the Great Palace	98
Technology and diplomacy	100
Monks, nuns and monasteries	100
7. The 'triumph of orthodoxy' and the impact of the image crisis	107
Theodora, Michael III, Methodios and the synod of 843	107
Representation and register: theology and practice	109
Icons in theory: the theology of icons	109
Icons in practice	111
8. Conclusions: the impact of iconomachy and the invention of 'iconoclasm'	115
The impact of the image struggle on Orthodox liturgy and artisanal production	116
Women and icons	117
The invention of 'iconoclasm'	120
Lazaros the painter	121
Other iconoclasms	124
Was 'iconoclasm' about icons?	125
Index	129

List of illustrations

Map 1. The Mediterranean and surrounding areas with major
 sites mentioned in this book. xi
Map 2. Constantinople and its surrounding area. xii
Map 3. Constantinople and its immediate hinterland. xiii
Map 4. Constantinople city plan. xiv

Fig. 1. King Abgar displaying the Edessa image of Christ. 12
Fig. 2. *Nomisma* (gold coin) of Justinian II: Christ (obverse)
 and Justinian II (reverse). 18
Fig. 3. Michael II (820-829) defeats Thomas the Slav with
 Greek fire, from the *Chronicle* of John Skylitzes. 26
Fig. 4. Constantinople, Hagia Sophia, *sekreton*: iconoclast cross. 36
Fig. 5. Nikaia, Koimesis church, apse mosaic (now destroyed). 37
Fig. 6. Constantinople, Hagia Eirene, interior with view
 toward apse. 40
Fig. 7. Vat. gr. 1291, fol. 2v: constellations of the northern
 hemisphere. 43
Fig. 8. Vat. gr. 1291, fol. 9r: sun table. 44
Fig. 9. *Follis* (copper coin), class 3, of Constantine V, struck at
 the Constantinople mint between 751-769, with Constantine
 V and Leo IV on the obverse and Leo III on the reverse. 56
Fig. 10. *Nomisma* (gold coin), class 1: Leo IV and Constantine
 VI (obverse) and Leo III and Constantine V (reverse), 776-778. 57
Fig. 11. Thessaloniki, Hagia Sophia, bema ceiling mosaic set
 under Constantine VI and Eirene. 65
Fig. 12. Trilye (Zeytinbağı), church plan. 67
Fig. 13. Constantinople, Monastery of St John the Baptist
 of Stoudios. 69
Fig. 14. Icon of saint Eirene with Nicholas of the Sabas
 monastery at her feet. 71
Fig. 15. Annunciation silk. 73
Fig. 16. Nativity silk. 74

List of illustrations

Fig. 17. Sasanian hunters silk. 75
Fig. 18. Amazon silk. 76
Fig. 19. *Nomisma* (gold coin): Constantine VI and Eirene (obverse), Leo III, Constantine V and Leo IV (reverse), 780-790. 77
Fig. 20. *Nomisma* (gold coin): Constantine VI and Eirene (obverse), Leo III, Constantine V and Leo IV (reverse), 790-792. 79
Fig. 21. *Nomisma* (gold coin): Eirene (obverse) and Constantine VI (reverse), 792-797. 79
Fig. 22. *Nomisma* (gold coin): Eirene (obverse) and Eirene (reverse), 797-802. 80
Fig. 23. *Nomisma* (gold coin): Leo V (obverse) and Constantine (reverse). 91
Fig. 24. Constantinople, Hagia Sophia, southwest vestibule, 'beautiful door'. 95
Fig. 25. Constantinople, Hagia Sophia, plan showing imperial route through church. 97
Fig. 26. Crucifixion and iconoclasts whitewashing an image of Christ. 123

Illustration credits

Figs 1, 14: reproduced by courtesy of the Michigan-Princeton-Alexandria expedition to Mount Sinai. Figs 2, 9, 10, 19, 20-3: The Barber Coin Collection, University of Birmingham. Fig. 3: Madrid, Biblioteca Nacional. Figs 4, 6, 24: © Dumbarton Oaks, Image Collections and Fieldwork Archives, Washington DC. Fig. 5: After T. Schmidt. Figs 7-8, 15-16: Vatican, Biblioteca Apostolica Vaticana. Figs 11, 13: Author. Fig. 12: From Cyril Mango and Ihor Sevcenko, 'Some Churches and Monasteries on the Southern Shore of the Sea of Marmara', *DOP* 27 (1973); by permission of Dumbarton Oaks. Fig. 17: Domschatz Cologne. Fig. 18: Collections du Musée Bossuet de Meaux (France), Cliché du Musée Bossuet, Dépôt de la Ville de Faremoutiers (France). Fig. 25: From Gilbert Dagron, *Emperor and Priest* (Cambridge University Press, 2003), plan 4.

Every effort has been made to trace copyright holders of illustrative material reproduced in this book. The Publishers will be pleased to hear from anyone with further information.

Abbreviations

Mansi = *Sacrorum Conciliorum Nova et Amplissima Collectio*, ed. J.D. Mansi (Florence, 1759ff.).

PG = *Patrologiae Cursus Completus*, series Graeco-Latina, ed. J.-P. Migne (Paris, 1857-1866, 1880-1903).

Map 1. The Mediterranean and surrounding areas with major sites mentioned in this book.

Map 2. Constantinople and its surrounding area.

Map 3. Constantinople and its immediate hinterland.

Map 4. Constantinople city plan.

Preface and Acknowledgements

Byzantine 'iconoclasm' was one of the most influential movements of the Middle Ages, and its repercussions are felt to this day. It changed the way Orthodox Christians worship, but its impact was far broader and reached into the early modern world and, beyond that, into the present. Promoters of the English Reformation in the sixteenth century, and the French Revolution of the eighteenth century, cited their Byzantine model; and in the contemporary world we need think only of the Taliban destruction of the monumental statues of Buddha at Bamiyan in 2001. Byzantine 'iconoclasm' has a lot to answer for, and it is something that we need to know about.

Information about Byzantine 'iconoclasm' is not hard to find. This information is, however, problematic. The prevailing understanding found in all standard handbooks and, now, on websites such as Wikipedia, is that it was instigated by the emperor Leo III in either 726 or 730; that it was a period of massive destruction of religious imagery across the Byzantine world; that it was hugely divisive, tearing apart Byzantine society; that it was a period of artistic stagnation; and that its fiercest opponents were monks and, possibly, women. **Every one of these assumptions is incorrect**. The point of this book is to correct them.

A note on names and dates

The Greek alphabet is different from the alphabet used for English. In this book, I have translated very familiar names into English (so Konstantinos becomes Constantine) but have avoided 'Latinising' whenever possible and have instead simply transliterated directly from the Greek (Nikaia, rather than Nicaea; Eirene rather than Irene).

The Byzantine calendar began with the creation of the world, which by the early ninth century was believed to have been 5508 years before the birth of Christ. The year began on 1 September, so that Byzantine sources that simply provide the year have no direct equivalent with our calendar: the Byzantine year 6255, for example, began on 1 September

762, by our reckoning, and ended on 31 August 763. For this reason, if all the Byzantine sources tell us is that an event occurred in 6255, we date it to 762/3; if we are told that it happened in November 6255, we can be more precise (by our reckoning) and date it to 762.

Acknowledgements

Much of the research that underpins this book was first published in two volumes – *Byzantium in the Iconoclast Era, c. 680-850: the sources*, Birmingham Byzantine and Ottoman monographs 7 (Aldershot, 2001) and *Byzantium in the Iconoclast Era, c. 680-850: a history* (Cambridge University Press, 2011) – both of which I co-wrote with John Haldon. My first and deepest thanks go to him, for well over a decade of fruitful collaboration.

Parts of Chapters 1-3 appeared in somewhat different form in my chapter of Liz James' *A Companion to Byzantium* (Oxford, 2009), and I am grateful to her for making me rethink the material. And much of the research presented here has been delivered as seminars or at workshops, the other participants of which have been uniformly stimulating. I would particularly like to thank the scholars and audience involved in the iconoclasm workshop at Dumbarton Oaks in September 2009 for sharing their broad perspectives on iconoclasm both within and outside of Byzantium, above all Richard Clay, a specialist on the French Revolution, who helped me organise the sessions and with whom I have discussed iconoclasm for many years.

I thank Ian Wood for inviting me to contribute to this series; and Deborah Blake for shepherding the manuscript through to production. My brother, Kevin Brubaker, manfully read through much of the text to ensure that it was accessible to the non-specialist; several of my doctoral students – Rebecca Day, Eve Davies, Julia Galliker, Andriani Georgiou, Eirini Panou, Daniel Reynolds, Roger Sharp, and Carol Shaw – read sections to make sure that they would be comprehensible to undergraduate history students. Rebecca Day prepared the maps; Stacey Blake and Andriani Georgiou sorted out plates and permissions; Graham Norrie made sure that they met his high standards of clarity and visibility.

Finally, as always, I thank my husband Chris Wickham, for everything.

1

Introduction: what is Byzantine iconoclasm?

Even more than the word 'Byzantine' itself, icons (as on our computers) and iconoclast (as a label for a cultural rebel) are probably the two Byzantine words that are the most familiar to twenty-first-century audiences. In a more academic realm, the related word 'iconoclasm' crops up in an apparently unlimited number of publications; and when I teach the history of Byzantium, 'iconoclasm' is nearly always the favoured topic for first-year essays.

None of these words – icons, iconoclast, iconoclasm – means the same thing to us as they did to the Byzantines. In fact, the word iconoclasm was unknown until the sixteenth century, and was not associated with Byzantium until the mid-twentieth century. Much of what we think we know about 'iconoclasm' turns out to be the product of medieval and modern 'spin', with authors rewriting the past to justify their own behaviours and beliefs. It is time to look at Byzantine 'iconoclasm' with fresh eyes.

In this introduction, I will first deal with terminology, which, as is evident from the last two paragraphs, needs clarification. Next, we will review the basic chronology of the period and quickly sketch an overview of our sources of information about Byzantium between about 650 and 850. Finally, I will outline the approach that will be followed in the rest of the book.

Who were the Byzantines?

Under the Roman emperor Diocletian (ruled 284-305), the Roman Empire was split into two halves for ease of administration. The eastern half extended from the Balkans (modern Greece and its environs) eastward into what we now call the Middle East, and included as well as

the coastal areas of modern eastern Libya, all of modern Egypt. This is what we now call Byzantium, but the people we call the Byzantines called themselves Romans, and called their territory the East Roman Empire.

A new imperial capital was established in 324, and dedicated in 330, by the emperor Constantine I (the Great), on the site of the much older settlement of Byzantion. Constantine re-named it Constantinople, after himself (*Konstantinoupolis* in Greek = Constantine's city in English), but the city's inhabitants continued to call themselves Byzantines, as well as Constantinopolitans. The misuse of the term Byzantine to include all people who lived in the empire began in the sixteenth century. The site of Constantinople is of great strategic importance because it controls access between the Mediterranean and the Black Sea; it became the largest and richest city in medieval Europe, and is still thriving under the Turkish version of its name, Istanbul.

Under Constantine I, Christianity had been officially recognised across the whole Roman Empire, and Christians could no longer be discriminated against. By the end of the fourth century, it was illegal to maintain 'pagan' temples, and Christianity became the dominant religion of the East Roman world. In the period covered by this book, the church was still at least nominally united between East and West, and ecumenical church councils – bringing together representatives of the five main administrative centres of the church: Rome, Constantinople, Jerusalem, Antioch, and Alexandria – continued until 787. Increasingly, however, Christian practice was regionally distinct. The main Byzantine form of Christianity was, and still is, called Orthodoxy (Greek for 'correct opinion'), and its highest officials were the patriarchs; after the mid-seventh century the only patriarchs of any political relevance were those of Constantinople and Rome (= the pope). The Orthodox administrative bureaucracy was situated in Constantinople, adjacent to the 'Great Church', also known as the church of Hagia Sophia ('Holy Wisdom').

By the period covered in this book – that is, roughly between the end of the seventh century and the middle of the ninth – the empire was much smaller than it had been in the fourth century. The Arab conquests, spurred by the conversion of influential sections of the Arabs of Arabia to Islam during the second quarter of the seventh century, removed North Africa and most of the Middle East from the East Roman Empire. The

1. Introduction: what is Byzantine iconoclasm?

East Roman/Byzantine Empire was by now in effect restricted to modern Turkey, Greece, and parts of Italy. As we shall see in Chapter 2, the Arab conquests had far-reaching consequences not only in Byzantine military and political spheres, but also for Byzantine social and cultural practice.

Terminology

Icon comes from the Greek word *eikon*, which means 'image', so the modern use of the term to indicate the little pictures on the screens of our various machines is not inaccurate. But in the Greek-speaking Roman world, before the advent of Christianity, *eikon* was usually used to describe portraits of humans. (The other dominant Greek words for image were *eidolon*, which became attached to non-Christian religious images – idols – and *agalma*, which usually designated images of Greek and Roman gods.) The word *eikon* was also backed by the authority of scripture. In the Greek-language Old Testament, when God says 'Let us make man according to our image' (Genesis 1.26), the word for image is *eikon*. Because it was not tainted by association with 'pagan' deities, and was authorised by its use in the Bible, the Byzantine world adopted the word icon to indicate a Christian religious portrait or scene. Icons could be in any medium, but in the early period they were normally painted in tempera or encaustic (wax mixed with pigment) on wood panels.

Iconoclast (Greek *eikonoklastes*) is a compound noun meaning 'breaker of images'. Its first recorded use is in a letter of the 720s, to rebuke a bishop who had removed religious portraits from his church without authorisation. It is then repeated constantly in the *Acts* of the seventh ecumenical council, held in Nikaia in 787, to canonise the veneration of icons, and to condemn those who were opposed to this practice; it appears sporadically thereafter to designate heretics. In sharp contrast to modern usage, where calling someone an iconoclast can imply approval, iconoclast is always a negative term in the texts which survive from the Byzantine world. It is sometimes used in opposition to the term **iconophile**, 'lover of images', which is normally a term of approval.

'Iconoclasm' is the word we use to mean the great debate about the role of religious images that occupied the Byzantine world from the early

seventh to the mid-ninth century. The Byzantines, however, would have been mystified by the term, and the assumptions that go with it in much modern scholarship, for 'iconoclasm' is neither a Byzantine, nor indeed a Greek word. The English word iconoclasm apparently derives from the Latin *iconoclasmus*, which first appears in print in the middle of the sixteenth century to describe the anti-image actions of the western churchman Claudius, who was made bishop of Turin in 816. It was attached – but only occasionally – to contemporary religious movements in the eighteenth century, when it was applied to Protestant opposition to religious art and to the destruction of church art during the French Revolution. But in the English-speaking world the word 'iconoclasm' was not attached to the Byzantine period until quite recently: it does not appear, for example, in the classic, eighteenth-century account of Byzantium by Edward Gibbon, and the earliest published example in English found by Jan Bremmer, who has studied the issue thoroughly, dates to 1953.

Iconomachy: Rather than using the word 'iconoclasm', the Byzantines called the debate about the legitimacy (or not) of religious images 'iconomachy', the 'image struggle', a word that is far more in keeping with what actually occurred, as we shall see. In a nutshell, Byzantine iconomachy was about the role of sacred portraits – of Christ, of his mother the Virgin Mary, and saints – in Christian worship. How and why this became an issue is the subject of Chapter 2; its consequences will be examined in Chapters 3 to 7.

Chronology: a brief sketch

The role of religious imagery became sufficiently important to warrant church legislation regulating its use in 691, and probably soon thereafter the emperor Justinian II took the innovative step of moving his own portrait to the reverse of his gold and silver coinage and placing an image of Christ on the front (Fig. 2 on p. 18). By the 720s the new power of images provoked a negative reaction strong enough to leave traces in historical sources, and the image struggle had begun.

The early years of iconomachy have left little trace in the written or archaeological evidence. It is only during the 750s, well into the reign of

1. Introduction: what is Byzantine iconoclasm?

the emperor Constantine V (741-775), that an imperial initiative to ban the production of religious portraits appears, apparently spearheaded by the emperor himself. After a series of debates with learned churchmen, Constantine V called a church synod in 754 which drew up legislation prohibiting the making of icons. The immediate results of this legislation are unclear, but certainly in the mid-760s some portraits of saints were removed from the church of Hagia Sophia and replaced by images of the cross, which the anti-image theologians deemed acceptable. When Constantine V rebuilt the church of Holy Peace (Hagia Eirene), near Hagia Sophia in the capital, he had it, too, decorated with a massive image of the cross.

The ban on religious portrait-production continued during the reign of Constantine V's son Leo IV (775-780), but was rescinded by the seventh ecumenical council, held at Nikaia in 787, during the reign of Leo IV's son Constantine VI and his mother, the empress Eirene. Again, the immediate results of the repeal are unknown, and the only major commission associated with Constantine VI and Eirene – mosaics in the apse of the church of Hagia Sophia in Thessaloniki, the second largest city of the empire – were non-figural.

Nikephoros I (802-811) and Michael I (811-813) maintained the status quo, but Leo V reintroduced the ban on icons, apparently in direct emulation of Constantine V. This continued during the reigns of his supplanter, Michael II (820-829), and Michael's son, Theophilos (829-842). After Theophilos' death, court officials persuaded his widow, the empress Theodora, and his young son, Michael III (842-867) to restore image veneration, which was agreed on condition that Theophilos would not be excommunicated (anathematised, in Orthodox parlance) for his past support of the ban. In 843 image veneration was reinstated once and for all, and soon thereafter this restoration began to be celebrated annually as the feast of the 'Triumph of Orthodoxy' on the first Sunday of Lent, a practice that continues to this day.

The sources

The primary sources of information for the period between *c.* 680 and *c.* 850 are written documentation, 'art' and architecture, and archaeological finds. I have put 'art' in inverted commas, because what we think of as

'art' – great works produced by individual artists of genius, and valued above all in museums – was unknown to the Byzantines. The role of painters, in particular, was scrutinised carefully during iconomachy, and we will be discussing this in some detail, but it is important to note from the outset that, while technical skill was highly valued, innovation and individuality in artistic expression was not considered desirable in our period: the artist as 'creative genius' did not exist. For this reason, I will call the producers of visual images artisans, rather than artists, throughout this book.

The written documentation for the years of iconomachy is often problematic, for three main reasons. First, it is often highly polemical and, like all polemical literature, prone to rhetorical exaggeration. Still, we can often tell what the author wants us to think was going on, which is useful in itself. Second, most iconoclast writing was destroyed after the 'Triumph of Orthodoxy', and much of the other documentation from this period was heavily re-worked after the end of the image debates. This often makes it a more reliable guide to what ninth- and tenth-century authors wanted posterity to think about iconomachy (and other things) than to what people involved in the debates themselves wanted to promote. Finally, most – though not quite all – of the preserved texts were written by a very small segment of the Byzantine population: urban élite males who lived in Constantinople. We have to remember all these issues when we read the surviving texts.

Archaeology and artisanal production have different problems, though both can at least provide a wider range of evidence, applicable to a broader spectrum of Byzantines, than do the written sources. But Byzantine archaeology is still in its infancy, and so there is less evidence than one would ideally like. Similarly, all too little visual imagery from the period has been preserved, and, again, most of it is from the capital or other major cities such as Thessaloniki.

Approach

These caveats aside, the combined resources of texts, archaeology and artisanal production allow us to understand reasonably well some of what happened – and why – during iconomachy. In what follows, I will take a broadly chronological approach to the material, with chapters on

1. Introduction: what is Byzantine iconoclasm?

the background to the image debates; the beginning and development of iconomachy; the iconophile intermission; the reintroduction of the image ban; and finally the 'Triumph of Orthodoxy'. Along the way, we will look at what else was happening in the East Roman Empire across the seventh, eighth and ninth centuries – for while iconomachy was a critical issue, it impacted on many things other than theology, and there was an important and wide ranging social and cultural transformation going on at the same time.

References

Bibliographic citations for all **quotations from Byzantine sources** that appear in the text are listed at the end of each chapter.

Bibliography

Here, and after each chapter, a basic bibliography lists the secondary literature that I have found most useful in constructing the chapter, and works in English (whenever possible) that will help the reader gain additional information. For a **detailed account of the entire period**, with full scholarly apparatus, see L. Brubaker and J. Haldon, *Byzantium in the Iconoclast Era, c. 680-850: a history* (Cambridge, 2011).

For **general reference**, see the A. Kazhdan *et al.* (ed.), *Oxford Dictionary of Byzantium*, 3 vols (Oxford, 1991).

For overviews of **Orthodoxy** and **Orthodox theology**, see M. Cunningham, *Faith in the Byzantine World* (Oxford, 2002); and M. Cunningham and E. Theokritoff (eds), *The Cambridge Companion to Orthodox Christian Theology* (Cambridge, 2008).

The new understanding of Byzantine iconomachy explored in this book has not yet reached most mainstream historical handbooks. Chapters on 'iconoclasm' are therefore often problematic. Aside from that, Judith Herrin's two overviews provide sensible and sensitive outlines of Byzantine history, and of Byzantine relations with others; Chris Wickham's two works already incorporate many of the findings presented here:

J. Herrin, *The Formation of Christendom* (Princeton NJ, 1987).

J. Herrin, *Byzantium: the surprising life of a medieval empire* (London, 2007).

C. Wickham, *Framing the Early Middle Ages: Europe and the Mediterranean, 400-800* (Oxford, 2005).

C. Wickham, *The Inheritance of Rome: a history of Europe from 400 to 1000* (London, 2009).

For the **seventh, eighth and ninth centuries** in Byzantium, see:

J. Haldon, *Byzantium in the Seventh Century: the transformation of a culture*, rev. edn (Cambridge, 1997).

L. Brubaker and J. Haldon, *Byzantium in the Iconoclast Era: a history* (as above).

For some of the **social underpinnings** of the period, see:

P. Brown, 'A Dark-Age crisis: aspects of the iconoclastic controversy', *English Historical Review* 346 (1973), 1-34.

A. Cameron, 'The language of images: the rise of icons and Christian representation', in D. Wood (ed.), *The Church and the Arts, Studies in Church History* 28 (Oxford, 1992), 1-42.

For the **terminology of 'iconoclasm'**, see J. Bremmer, 'Iconoclast, iconoclastic, and iconoclasm: notes toward a genealogy', *Church History and Religious Culture* 88 (2008), 1-17.

On **church legislation** concerning images, and the **coinage of Justinian II**, see Chapter 1.

For the **sources**, see L. Brubaker and J. Haldon, *Byzantium in the Iconoclast Era, c. 680-850: the sources*, Birmingham Byzantine and Ottoman monographs 7 (Aldershot, 2001).

2

The background

To understand why religious images became important enough to give rise to iconomachy, we need to look at earlier developments in religious belief and political history. Religion and politics are usually studied from top down, taking the point of view of the governing bodies and administrative systems of the church and the state as institutions. This is certainly important, and there were major cultural and social transformations across the seventh century that are most easily tracked at the level of institutional change. But the Byzantine struggle over images did not begin at this institutional level, and its background must be sought in the day-to-day practice of the Byzantine populace.

Belief and practice

Orthodox religious faith in the Byzantine world was based on the belief that Jesus Christ's incarnation (his life in the flesh; that is, on earth) and his death on the cross brought salvation to humanity: 'Christ died for our sins' is a recurring refrain in Orthodox worship. This dogma was underpinned by confidence in two inter-related concepts: hierarchy and intercession.

The Orthodox hierarchy: The Trinity (father, son and holy spirit) sat at the top of the Orthodox hierarchy, and, because of his incarnation, Christ (the son) was its most accessible member. Below the Trinity was Christ's mother, the Virgin Mary – in our period usually called Theotokos, 'bearer of God', or, by the ninth century, *meter theou*, 'mother of God' – and then followed the saints and martyrs. Further down the hierarchical chain sat holy men or women, and various spiritual advisors, followed by the rest of humanity.

Intercession: The Orthodox hierarchy determined how believers asked for divine help. We have no way of knowing how individuals prayed in private, but when requests for help – healing from illness, safety from danger, a desired pregnancy, resistance to temptation, and the like – were recorded in texts or in images, God was rarely invoked directly. Instead, humans asked an intermediary (usually a saint or the Virgin, but sometimes a living person believed to be sufficiently holy to have special access to the divine) to arbitrate or intervene on their behalf with Christ.

The *Miracles of St Artemios* (mostly written down between 658 and 668, in Constantinople) provide a good example. Of the forty-five miracles recorded, nine involve mothers asking for their children to be healed. The healings follow a set pattern: Artemios appears to the mother in a dream or vision, touches the ailing child or makes the sign of the cross over it, and explains that the child is healed through Christ. The mother has asked the saint to help her child; the saint has asked Christ, and then returns to tell the mother that Christ has granted his request.

The cult of saints and the cult of relics: As intermediaries, the saints became cast as 'friends of God' and, as Peter Brown was first to recognise, thus played a very different role from the gods of antiquity. What is often called the cult of saints resulted from people's attraction to these heavenly helpers. Probably by the end of the fourth century, and certainly by the mid-fifth, this was joined by a conviction that the holiness of saints remained attached to their bodies after death. Burial in close proximity to a saint's tomb (burial *ad sanctos*, to use the Latin phrase), built on this belief in the importance of physical presence, and was intended to ensure saintly intervention on one's behalf at the doors of heaven. This led, in turn, to a cult of relics, based on the belief that the power of the saint to intercede with Christ continued to be exerted even when the body had been dismembered – so parts of the saintly body (or even objects that had come into contact with the body or bones of a saint) had the same 'real presence' as the complete body.

Here, a good example is provided by the fourth-century Church Father, Gregory of Nyssa, who wrote about the relics of St Theodore: 'Those who behold them embrace them as though the very body were living and flowering, and they bring all the senses – eyes, mouth, ears – into play; then they shed tears for his piety and suffering and they

2. The background

address to the martyr their prayers of intercession as though he were present and whole'.

Relics, images and icons

In the Byzantine world, the 'real presence' of the saint in his or her relics gradually became associated with portraits of the saints as well. This did not happen overnight, and it only happened in Byzantium, not in the Christian West. How and why did icons become assimilated into the cult of saints and relics in the East Roman Empire?

Images not-made-by-human-hands: The first images credited with special powers were those that most closely resembled relics, the images 'not-made-by-human-hands' (*acheiropoietoi*), and we begin to hear about them in the later sixth century. None of the three earliest examples known from texts survive, but documentary accounts, and in one case a tenth-century icon that pictured the relic (Fig. 1), indicate that all portrayed Christ on a piece of linen cloth – much like the later, still-preserved shroud of Turin. The earliest known of these, described in a text written in 569, is said to have been found floating in a well – where it miraculously remained dry – in Kamoulianai in Syria. The next, in Memphis (Egypt), was created when Christ pressed the linen cloth to his face, as we are told in a pilgrim's account of his journey to the Holy Land, written around 570. The so-called mandylion of Edessa, first attested c. 590, was the most famous of them all during the Byzantine period, and it too was said to have been produced when Christ pressed his face against a linen cloth. It is the Edessa *acheiropoietos* that is pictured on the icon in Fig. 1, which was probably painted to celebrate the relic's arrival in Constantinople in 944.

All we know about the Memphis image is that it was very bright and 'changed before your eyes'. The Kamoulianai image, however, was probably the famous *acheiropoietos* that was paraded around the walls of Constantinople in 626 and thus miraculously saved the city from Avar and Persian attack, while the Edessa image was said to have protected that city too from the Persians.

The earliest powerful images in Byzantium were, then, miraculous relics of Christ (not saints) that acted as protectors of cities. In this,

Fig. 1. King Abgar displaying the Edessa image of Christ.

2. The background

they acted very much like the old Roman *palladia*, statues of a city's patron god or goddess that protected that city from harm, as at least some Byzantines were well aware. The seventh-century *Paschal Chronicle*, for example, tells us that when Constantine I moved his power-base from Rome to Constantinople in 324, he secretly took Rome's *palladion* – effectively its protective deity – with him, presumably to ensure the superior protection of his own new capital.

Icons made by human hands: The earliest written accounts of Christian portraits made by human hands condemn them as 'pagan'. In the second century, Irenaeus described a woman hanging wreaths on a portrait of Christ, but only in order to use this practice as proof that the woman was a heretic. Similarly, in the third-century (?) *Acts of John*, a man hangs garlands on and lights candles before an image of John the evangelist, prompting John to exclaim 'Why, I see you are still living as a pagan!'.

It seems to have been the special attention given to these images – the embellishment with wreaths and the illumination with candles – that was seen as un-Christian, for there is ample documentary evidence of painted religious scenes and portraits from the fourth century onwards, though the 'pagan' accoutrements of garlands and candles appear to have been mostly avoided during the fourth, fifth, and sixth centuries. Fears of 'acting pagan' may also explain why, until the last quarter of the seventh century, the surviving texts from this period give little indication that sacred portraits were venerated in any special way. Instead, the literary sources speak of images intended to preserve the memory of the person represented, to provide an inspiring model for imitation, to honour the figure portrayed, or to express thanks to a saint who has answered a prayer (*ex voto* images).

The changing role of icons: The status of images, icons, changed perceptibly toward the end of the seventh century in the Byzantine world (though not in the Latin-speaking West). They are mentioned more often in texts: Anastasios of Sinai, for example, invokes them regularly in his *Guidebook* (*Hodegos*) of the 680s. In the 690s images are mentioned favourably for the first time in anti-heretical polemic; in the same decade, in the writings of Stephen of Bostra, we first hear positive references to icons honoured with candles, curtains and incense,

accoutrements that had until then been reserved for relics. In 691/2 the Quinisext Council (also known as the Council in Trullo) issued the first ecumenical church legislation concerning images. Whether or not sacred portraits were sometimes and sporadically venerated before this, by the end of the seventh century icons had taken on a much more significant and ubiquitous role in the Byzantine textual record than they had played previously.

How this worked in practice is suggested by a contemporary western pilgrimage account. The Irishman Adamnán tells us that the Anglo-Saxon Arculf went on pilgrimage to the Holy Land in 683/4, and that he (Adamnán) recorded his account of the journey sometime before 688. Adamnán included a tale Arculf is said to have heard from story-tellers in Constantinople. A man about to set off on a great military expedition stood before a portrait of the confessor George, and 'began to speak to the portrait as if it were George present in person'; he asked 'to be delivered from all dangers by war'. Adamnán then tells us that 'It was a war full of danger, and there were many thousands of men who perished miserably. But he ... was preserved from all misadventure by his commendation to the Christ-loving George, and by the grace of God came safely back ... and spoke to St George as though he were present in person' again. The story of the man and the icon circulating in Constantinople in the 680s was evidently striking enough for Adamnán to include it (there is only one other mention of icons in the entire text). And in the tale, the portrait is treated like relics had been since the fourth century, as a site of the saint's presence: George's image can be spoken to 'as though he were present in person'.

It is significant that this, the oldest fully fleshed-out account of an icon standing in for the figure portrayed, is linked with a soldier setting off to, and returning safely from, a war. We are not told what war it was in the story but, at the end of the seventh century, the major battles a pilgrim travelling across Byzantium to the Holy Land was likely to have in mind were the skirmishes with the Arabs at the tail end of the Islamic conquest. The absorption of 'normal' icons into the cult of saints and relics must be considered in the context of the Islamic conquests and the wars of the later seventh century.

2. The background

The Persian war and the Islamic conquests

The first half of the seventh century saw the Byzantine Empire almost constantly at war. The Persians spilled into Anatolia in 611 and had reached the Bosphoros by 616/7; along the way they took Syria (in 613) and Palestine (in 614), and they conquered Egypt in 619. The latter was particularly significant, because Egypt had been one of the richest and most fertile regions of the empire; it had supplied both the grain for the food supply of the capital and gold in tax payments that sustained the army. The emperor Herakleios was forced to concentrate his forces on defending the Byzantines against the Persians, which left the Balkans open to infiltration by the Avars, who were based north of the Danube. The two enemies of Byzantium joined forces in 626, and together attacked Constantinople. Herakleios was with the troops in Armenia, and had left the capital's defences in the hands of the *patrikios* (patrician) Bonos and the patriarch Sergios. Their defence was successful, and the Persians and Avars were repelled. The Byzantine ability to withstand the combined Persian and Avar attack is ascribed by modern scholars to the strong walls of Constantinople. The Byzantines, however, gave credit for the victory to an image not-made-by-human-hands – perhaps the Kamoulianai *acheiropoietos* discussed earlier – that the patriarch Sergios carried round the walls in a prayerful procession, and the protection of the Virgin Mary, patroness of the capital. In her honour, the most famous hymn of the Byzantine world, the *Akathistos* ('not seated'), was written shortly thereafter, to commemorate the standing all-night vigil held the night before the battle beseeching the Virgin's aid.

After the failed siege of 626 the Avars were no longer a threat, and Herakleios moved quickly and successfully into the Persian political heartland (modern Iraq); the defeated Persians ultimately made peace in 628, returning all lands to Byzantium. But the military infrastructure of both sides was exhausted, leaving little reserve to combat the threat that arose almost immediately, from the Arabs.

The prophet Mohammed died in 632, by which time he had unified the tribes across Arabia under the banner of Islam (which means 'submission' to God, Allah). This was an extraordinary achievement, and proved catastrophic for Byzantium, for Mohammed's successors, the

caliphs, regarded conquest for the new faith (later formulated as *jihād*, striving in the path of God) as intrinsic to their mission. In 637, Syria – only recently recovered from the Persians – fell to the Arabs, quickly followed by Palestine (including Jerusalem) and the area between the Tigris and Euphrates rivers in the late 630s, Egypt between 640 and 645, and all the rest of Persia between 639 and 650. Byzantium lost about two-thirds of its lands, and mostly those, like Egypt, it could ill afford to lose. That the empire survived at all is probably largely due to bouts of internal dissension amongst the Arabs, which gave Byzantium occasional breathing spaces to recover resources and regroup, and the strong fiscal bureaucracy based in Constantinople, which ensured that taxes continued to be collected – and the army continued to be supplied – even under duress.

By the middle of the seventh century, there were thus huge populations of formerly Byzantine Christians living under Arab rule (the caliphate), in Syria, Palestine and Egypt. They were allowed to keep their faith, with some restrictions, and Christian churches continued to be built and decorated. Perhaps the greatest inconvenience to Christians in the caliphate was the requirement to pay special taxes not required of Muslims.

In the lands the Arabs had not conquered, however, there was continual military raiding, particularly in Anatolia (what is now central Turkey), and a sense of crisis which only began to abate after the last major Arab raid on the Byzantine heartland, the failed attack on Constantinople in 717/8.

Why did the role of icons change around the year 680?

The bulk of the Islamic conquest of Byzantine territory was nonetheless over by the 660s, and the late seventh century was a relatively peaceful period for much of the empire. But it was precisely then – perhaps because there was time to think and to write – that eastern Christians began to record a heightened sense of anxiety, including a belief that, as John of Phenek wrote around 686, 'the end of the world has arrived'. The realisation that Islam was not going to disappear, and that the former Byzantine territories of Egypt, Syria and Palestine were not going to be recovered, unleashed a spate of apocalyptic texts, mostly written by

2. The background

Christians living in the lands now under Arab control. The late seventh century was clearly a troubling time for Christians in the former East Roman Empire, and the critical destabilising factors were religious and financial insecurity.

The *Acts* of the Quinisext council of 691/2 were written in Constantinople, far away from the military fronts, but they also reveal anxiety about the fate of Christianity and Christians. Here, however, the Byzantine churchmen expressed their unease by increasing their attempts to control what was still in their power to manage. These attempts to impose order were mostly articulated through increasing regulation, and by inventing new processes to ensure the purity of Christian ritual. As mentioned earlier, the *Acts* provide the first Byzantine canonical legislation about religious images, and three canons (laws) were directed at artisanal production in what appears to have been an attempt to regulate and control the new powers of sacred images. Canon 73 forbade decorating the floor with signs of the cross; canon 82 dictated that Christ should be represented in human form rather than symbolically as a lamb; and canon 100 insisted on the distinction between good and bad pictures, defining the latter as images that evoked 'the flames of shameful pleasures'. What is new here is, first, the insistence that historical representation (Christ's portrait) must replace symbolic metaphor (Christ as the lamb of God); and, second, the insertion of images into standard Byzantine arguments about the virtues of purity and truth over defilement and corruption. Both of these issues became bones of contention during the debates about images in the eighth and ninth centuries; and at heart both express a need, generated by anxiety and insecurity, for exactitude and certainty in the production of Christian imagery. While the urge to control and regulate is symptomatic of this period of unease, the decision to focus on the control of images is a direct response to the new power of icons, which, as we have seen, had become evident in the documentary sources around the year 680, a decade before the Quinisext Council.

The uncertainty that underlay the Quinisext churchmen's efforts to standardise and cleanse Orthodox practice finds echoes in many other contemporary sources. For example, Anastasios of Sinai, in a text probably composed at the very end of the seventh century called *Questions and Answers*, wrote that the 'present generation' was enduring a period of spiritual crisis. Both the *Acts* and Anastasios find many parallels: in his

classic account of the seventh century, John Haldon has noted that at the end of the century a desire for internal purity was the recurring theme of church and state rhetoric.

By the third quarter of the seventh century, the state, the church, and many individual Orthodox believers were in a state of spiritual crisis. They needed reassurance, and this took two forms. First, ways to access divine help appeared. The 'real presence' of saints offered by miracle-working relics and images not-made-by-human-hands was expanded to include portraits painted by living people (and, eventually but probably not quite yet, justified by new ways of thinking about the relationship between the painter and the painted). Second, new rules and new rituals of purification were devised to control and regulate holy power, including in these new forms, and to ensure that God would look upon the 'chosen people', the Orthodox, with favour once again.

Conclusions

Icons took on new significance at the end of the seventh century because they addressed the spiritual crisis and insecurities brought about by the Islamic conquests. The ramifications were almost immediate. Changes in practice by around the year 680 generated, a decade later at the Quinisext Council of 691/2, the institution of canonical legislation regulating the proper use of Christian imagery. Apparently soon thereafter, and perhaps inspired by the legislation of the 691/2 council, the emperor Justinian II (685-695, 705-711) introduced a radical new design for the most important coinage of the empire, the gold *nomisma*. For the first

Fig. 2. *Nomisma* of Justinian II: Christ (obverse) and Justinian II (reverse).

2. The background

time, the portrait of the emperor was moved to the reverse, and, also for the first time, a portrait of Christ appeared on Byzantine coinage, prominently displayed on the front (obverse) of the coin (Fig. 2). This was a blatant imperial stamp of approval for the new power of Christian portraiture and, perhaps, an attempt to harness some of that power for the continued security of the empire. But all was not plain sailing for the Orthodox image, for a backlash was in the making. The following generation of churchmen, active in the 720s, reacted against the new role of icons and provide our earliest documented iconoclasts.

References

For the **Artemios miracles** (p. 10), see V.S. Crisafulli and J.W. Nesbitt, *The Miracles of St Artemios*, The Medieval Mediterranean XIII (Leiden, 1997), miracles 10-12, 28, 31, 36, 42-3, 45 (pp. 94-101, 154-7, 162-5, 188-93, 216-19, 222-5).

For **Gregory of Nyssa**'s *enkomion* on St Theodore, quoted on p. 10, see P. Brown, *The Cult of the Saints: its rise and function in Latin Christianity* (Chicago, 1981), 11; the Greek may be found in PG 46: 740B.

For the **Kamoulianai** image noted on p. 11, see F.J. Hamilton and E.W. Brooks, *The Syriac Chronicle known as that of Zachariah of Mitylene* (London, 1899), 320-1; for the **Memphis** image, recorded by the Piacenza pilgrim, see J. Wilkinson, *Jerusalem Pilgrims before the Crusades* (Warminster, 1977), 88 (§44); for the **Edessa** image, see A. Cameron, 'The history of the image of Edessa: the telling of a story', *Okeanos: essays presented to Ihor Ševčenko*, Harvard Ukranian Studies 7 (Cambridge, 1983), 80-94; reprinted in *eadem*, *Changing Cultures in Early Byzantium* (Aldershot, 1996), essay XI. On the **icon** which depicts it, see K. Weitzmann, *The Monastery of Saint Catherine at Mount Sinai, The Icons I: from the sixth to the tenth century* (Princeton NJ, 1976), 94-8.

For the *Paschal Chronicle* account (p. 13), see M. and M. Whitby (tr.), *Chronicon Paschale 284-628 AD*, Translated Texts for Historians 7 (Liverpool, 1989), 16.

On **Irenaeus** (p. 13), see T. Mathews, *The Clash of Gods: a reinterpretation of early Christian art*, rev. edn (Princeton, 1999), 177-8; for the quotation from the *Acts of John* see E. Hennecke and W. Schneemelcher, *New Testament Apocrypha*, 2 vols (Philadelphia PA, 1965), 220.

For **Anastasios of Sinai**'s writings (p. 13), see Brubaker and Haldon, *Byzantium in the Iconoclast Era: the sources* (as in Chapter 1), 254; for **Stephen of Bostra** and the anti-heretical texts, see *ibid.*, 268-9; and for the **Quinisext Council**, see G. Nedungatt and M. Featherstone (eds), *The Council in Trullo Revisited*, Kanonika 6 (Rome, 1995).

For **Adamnán**'s account (*On the Holy Places*, 231-2) quoted on p. 14, see Wilkinson, *Jerusalem Pilgrims* (as above), 114-15. As Thomas O'Loughlin has argued vigorously, *On the Holy Places* is less a travelogue than a theological treatise (and it is dominated by Adamnán's theology rather than Arculf's memories), but this does not diminish the value of the story about the soldier and St George for the argument presented here: T. O'Loughlin, *Adomnán and the Holy Places: the perceptions of an insular monk on the locations of the biblical drama* (London, 2007).

For **John of Phenek**'s phrase quoted on p. 16, see S. Brock, 'Syriac views of emergent Islam', in G. Juynboll (ed.), *Studies on the First Century of Islamic Society* (Carbondale IL, 1982), 9-21, 199-203, at 15-17; repr. in *idem*, *Syriac Perspectives on Late Antiquity* (London, 1984).

For the passages from the **Quinisext Council** discussed on p. 17, see Nedungatt and Featherstone (eds), *The Council in Trullo Revisited* (as above), 155, 162-4, 180-1.

For the quote from **Anastasios** on p. 17, see J. Haldon, 'The works of Anastasios of Sinai: a key source for the history of seventh-century east Mediterranean society and belief', in A. Cameron and L. Conrad (eds), *The Byzantine and Early Islamic Near East I: problems in the literary source material*, Studies in Late Antiquity and Early Islam I (Princeton NJ, 1992), 107-47, at 132.

Bibliography

On the **cult of saints**, see Brown, *The Cult of the Saints* (as above).

On **icons before the late seventh century**, see L. Brubaker, 'Icons before Iconoclasm?', *Morfologie sociali e culturali in europa fra tarda antichità e alto medioevo*, Settimane di Studio del Centro Italiano di Studi sull'Alto Medioevo 45 (1998), 1215-54.

On **Roman** *palladia*, see R. Gordon, 'The real and the imaginary: production and religion in the graeco-roman world', *Art History* 2 (1979), 5-34.

2. The background

On the writings of **Christians living in Arab territories**, see Brock, 'Syriac views of emergent Islam' (as above); R. Hoyland, *Seeing Islam as Others Saw it: a survey and evaluation of Christian, Jewish and Zoroastrian writings on early Islam*, Studies in Late Antiquity and Early Islam 13 (Princeton NJ, 1997); A. Cameron and L. Conrad (eds), *The Byzantine and Early Islamic Near East I: problems in the literary source material*, Studies in Late Antiquity and Early Islam I (Princeton NJ, 1992).

On the **seventh-century crisis**, see J. Haldon, *Byzantium in the Seventh Century: the transformation of a culture*, rev. edn (Cambridge, 1997). On the rhetoric of internal purity see also Haldon's article on Anastasios of Sinai, cited above, esp. pp. 144-5.

On the **Persian wars**, see W. Kaegi, *Heraclius, Emperor of Byzantium* (Cambridge, 2003); Haldon, *Byzantium in the Seventh Century* (as above).

On the **Islamic conquests**, see F. Donner, *The Early Islamic Conquests* (Princeton, 1981); H. Kennedy, *The Prophet and the Age of the Caliphates* (London, 1986); W. Kaegi, *Byzantium and the Early Islamic Conquests* (Cambridge, 1992); Haldon, *Byzantium in the Seventh Century* (as above). On **jihād**, see P. Crone, *Medieval Islamic Political Thought* (Edinburgh, 2004), 362-73.

On **Christian communities in Arab territories**, see R. Schick, *The Christian Communities of Palestine from Byzantine to Islamic Rule*, Studies in Late Antiquity and Early Islam 2 (Princeton NJ, 1995).

On the **coinage of Justinian II**, see J. Breckenridge, *Numismatic Iconography of Justinian II* (New York, 1959).

3

The beginnings of the image struggle

It was probably inevitable that there would be some resistance to the new power of images. Because a painted portrait of St George (or any other saint, including the Virgin Mary) could now be spoken to 'as though he were present in person' it is easy to understand that some people might be uneasy – how could a piece of wood painted with a figure channel a believer's prayers to the saint portrayed? What was the difference between honouring an icon and worshipping a pagan idol, which the second commandment – which reads: 'Thou shalt not make to thyself an idol, nor likeness of anything ... Thou shalt not bow down to them, nor serve them ...' (Exodus 20:4-5) – clearly prohibited? It would take Orthodox churchmen several decades definitively to sort out the difference between an icon and an idol, and several more decades to create a theology that fully incorporated the role of icons. That they felt the need to do this provides a clear indication of just how strong the urge to justify the new role of icons was. First, however, came the backlash.

Constantine of Nakoleia, Thomas of Klaudioupolis, and local reactions against religious images

The debate about images apparently began in the 720s. We first hear about it in three letters of the patriarch Germanos (patriarch 715-730) concerning two churchmen, Constantine of Nakoleia and Thomas of Klaudioupolis. The letters date to the 720s and, probably, the early 730s after Germanos had retired.

The earliest two letters both concern Constantine, the bishop of Nakoleia (a city in Phrygia, roughly 300 km south-east of Constantinople) and, in both, Germanos expresses his annoyance at Constantine's unexpected behaviour. According to Germanos, Constantine had refused

3. The beginnings of the image struggle

to honour images by bowing before them (this form of honorific bowing or prostrating is called *proskynesis*). As best we can understand from the letters, Constantine apparently reasoned that such honour was due only to God, but Germanos wrote that he had – or so he thought – convinced Constantine that the honour shown to sacred portraits and that shown to God was different in kind. According to Germanos, Constantine had agreed to uphold tradition, and to do nothing which might give rise to a scandal or cause confusion among the populace: in other words, he had capitulated to Germanos' demand to honour icons. On his return home, Constantine had, however, retreated to his earlier, anti-image position.

Germanos' first letter was addressed to Constantine's superior John, the bishop of Synada, and treats Constantine's behaviour as a case requiring local disciplinary action: Germanos asks John to resolve the problem with Constantine quietly and unobtrusively. In the second letter, addressed directly to Constantine, Germanos reprimanded him for acting behind his back and against his authority. It is never precisely clear what Constantine actually did – other than refuse to bow before icons – but Germanos' letters to or about the bishop of Nakoleia demonstrate that at least one churchman was worried about the authority of sacred portraits in the 720s. Germanos is chiefly worried, however, about Constantine causing a local scandal or confusing his parishioners. There is no evidence from anything that Germanos wrote that Constantine's anti-image behaviour was widespread.

The latest of the three letters, to Thomas of Klaudioupolis (which was under the ecclesiastical jurisdiction of Constantinople, as it was closer to the city), is different in tone, and was probably written after Germanos retired from the patriarchate in 730. Thomas had stayed with Germanos, and Germanos writes that he remembers their conversations, which had given him no inkling that on his return to Klaudioupolis, Thomas was going to remove the icons from his church. Germanos protested strongly: Thomas' conduct gave Jews and Muslims the opportunity to slander the church; his removal of icons from the church went against tradition and scripture; and by removing images of the saints he was denying his congregation inspirational models of behaviour. Germanos distinguished between idolatry and icon veneration, and provided a theological justification for sacred portraits, noting that the honour accorded to holy images was directed not to the material of which the

images were made, but to the person represented. Finally, Germanos demanded that Thomas avoid arousing anger and confusion in the Christian community, and reminded him that 'the Christ-loving and most pious emperors' (Leo III and his son Constantine V) had erected an image in front of the palace, portraying the apostles, prophets and the cross, as a demonstration of imperial faith.

Germanos' letter to Thomas indicates that by the 730s the anti-image arguments were no longer simply a localised concern in Nakoleia, but had become more widespread, and had moved closer to the imperial capital. It is also much clearer in this letter what actions had actually been taken: Thomas had physically removed icons from his church. And the beginnings of the Orthodox argument in favour of images are also here: first, icons are not idols; and, second, honour is directed to the person represented, not to the icon itself. As in the letter to Constantine of Nakoleia, Germanos was particularly concerned to ensure that Thomas avoided confusing the local Orthodox community and giving ammunition to enemies of the church (Jews and Muslims). Finally, Germanos framed Thomas' action as going against both the practices of the church and the practices of the state. There is no evidence that the image struggle began as an imperial initiative. Quite the contrary, in fact: Germanos implies that the reigning emperors were friends of icons, who had themselves installed religious images in the environs of the palace.

The political backdrop: Leo III's rise and achievements

Our understanding of Leo III's rule (717-41) is based almost entirely on textual evidence, with little material culture aside from coins and seals to augment the written sources. Though, as we have just seen, Germanos ascribed an image of prophets, apostles and the cross to Leo's initiative, and a later text credits the emperor with erecting a statue at the harbour of the capital, the only material remains from the second quarter of the eighth century in Constantinople are sections of the land walls, where inscriptions document imperial repairs after an earthquake in 740.

The textual evidence is, however, sufficient for us to understand the circumstances surrounding Leo's rise to power, and many of his achievements. The real problems come when we try to understand his attitudes toward icons.

3. The beginnings of the image struggle

Leo's rise to power: The dynasty founded by Herakleios in 610 ended with the overthrow and death of Justinian II in 711. A period of instability ensued, with three emperors following each other in quick succession over the next six years. In the West, the Bulgars (only recently united as a state in what is now Bulgaria) penetrated Thrace almost as far as Constantinople, until a frontier was established during the short reign of Theodosios III (715-17). In the East, the area around the Tauros mountains had been ravaged by Arab raids; and the Arabs were known to be planning to besiege Constantinople any minute.

Against this background of chaos, in 717 Leo the Isaurian – commander of one of the major army divisions of the empire, the *Anatolikon* – and the general Artabasdos announced their opposition to the current emperor, Theodosios III, and marched toward Constantinople. Theodosios capitulated almost immediately, and, assured of safety for himself and his family, abdicated to become a monk in Ephesos.

Leo and the Arabs: On 25 March 717 (the feast of the Annunciation) Leo was crowned by the patriarch Germanos in Hagia Sophia, thus inaugurating a new dynasty, the Isaurians, which would rule Byzantium until the end of the century. Within months he faced a major crisis, the approaching army and fleet of the Arab general Maslama. Maslama's ships blockaded the capital, but the Byzantines were prepared for a long siege, and successfully defended the city land and sea walls, doing considerable damage to Maslama's navy with the famous Byzantine weapon 'Greek fire' – a kind of liquid napalm that shot across the water burning everything with which it came into contact (Fig. 3) – which had probably been introduced in the 660s. Leo claimed a major victory in Bithynia (east of the capital), and with the Bulgars attacking the rear of the Arab forces in Thrace to the West, and an outbreak of disease in the Arab camp, Maslama abandoned his siege in 718. Though annual raids continued, Maslama's was the last Arab attack on Constantinople, and the last Arab attempt to conquer the Byzantine Empire with a single, convulsive battle.

Leo's reforms: After 718, Leo III was thus able to consolidate his authority. He instituted wide-reaching administrative reforms across the

Fig. 3. Michael II (820-829) defeats Thomas the Slav with Greek fire, from the *Chronicle* of John Skylitzes.

state's military and fiscal machinery, and commissioned a revised law code, the *Ekloge ton nomon* ('Selection of the laws'), which appeared in 741. Though based on the earlier sixth-century code of Justinian, the *Ekloge* introduced a number of changes, particularly in laws relating to marriage, the family, and the nature of punishment. In Roman law,

3. The beginnings of the image struggle

and the Justinianic code, crimes were normally punished by capital punishment or fines; the *Ekloge*, following the Old Testament, added corporal mutilation. The influence of Christianity on civil law is here clear, and the emphasis on an Old Testament model followed the seventh-century belief that the Byzantines had succeeded the Jews of the Old Testament as the chosen people of God.

In the prologue (*prooimion*), Leo recognised the social changes which had taken place since the composition of the Justinianic law code in the sixth century, and stressed the need to preserve the law as the foundation of God's will and the emperor's divinely-sanctioned authority. The law, he says, must be more easily accessible, and corruption must be stamped out. (To that end, the representatives of justice were henceforth to be given proper and adequate salaries.) In the context of the forthcoming image struggles, this is important for two reasons. First, it provides a clear demonstration of the perceived need to cleanse and purify existing institutions that we noted in the last chapter. Second, it cements the special relationship between the emperor and God. How this was to be balanced with the role of the church hierarchy became another issue during the period of iconomachy and its immediate aftermath.

Leo's accomplishments in securing the capital against further Arab attack, administrative reform, and the overhaul of the legal system are noteworthy. They have, however, been overshadowed in virtually all assessments of his leadership by Leo's supposed instigation of 'iconoclasm'. This, as we shall see, is more problematic than was once thought.

Was Leo III an iconoclast?

It used to be assumed without question that the emperor Leo III was a fervent iconoclast, responsible for unleashing the anti-icon movement by removing an icon of Christ from above the main ceremonial entrance to the palace, the Chalke gate, in either 726 or 730, perhaps as a reaction to a volcanic eruption on the Aegean island of Thera. This assumption rests on three documents, all of which are problematic.

The first document is the *Liber Pontificalis*, the *Book of the Popes*, which records (in largely contemporaneous entries) papal events that occurred across the eighth and ninth centuries. Though written very much from

the papal point of view, and dominated by events in Rome and Italy, Byzantine affairs are sometimes recorded, particularly when the pope in Rome was in conflict with the emperor in Constantinople. During Leo III's reign, the entries for both Gregory II (pope 715-31) and Gregory III (pope 731-41) refer to Leo at various points, mostly with regard to arguments about taxation and skirmishes over land ownership, for Leo removed revenues from Sicily and southern Italy from the popes. There are three brief mentions of Leo's actions against icons, but all have been shown to be later insertions intended to enhance the anti-iconoclast credentials of the popes retrospectively. There is, in short, nothing genuine in the *Book of the Popes* that indicates whether or not Leo III took sides in the icon struggle that was developing during his reign.

The second and third texts concerning Leo and image destruction are the *Life* of Stephen the Younger, written by Stephen the Deacon, and the *Chronicle* of Theophanes. These are problematic because both are almost viscerally anti-iconoclast documents, and both were written 80 years after the events they purport to describe. Both Stephen the Deacon and Theophanes are particularly anxious to vilify the emperor of their youths, Constantine V (741-775), who was the son of Leo III. As the progenitor of Constantine V, Leo is therefore also presented in a very bad light indeed.

These two texts preserve the earliest versions of the (almost certainly fictitious) story of Leo's orders to remove an icon of Christ from the palace gate. The *Life* of St Stephen the Younger, written in 807 or 809, tells us that the emperor Leo sent an officer to remove the Chalke portrait. The officer was knocked from his ladder to the ground and killed by a group of honourable women, 'moved by zeal', who then advanced to the patriarchate and, blaming the patriarch Anastasios for the incident, stoned him. The patriarch fled to the emperor and persuaded Leo to put the 'holy women' to death, after which we are assured that 'they rejoice with all of the other holy victorious athletes [martyrs] in heaven'. Many details of this saga are hard to believe, but 'the truth' is surely not the point here: this is a moral tale. Like David and Goliath, the good but weak women are portrayed as victorious over the evil but strong state official and patriarch. A different version of the story appeared a year or so later (between 810 and 814) in the *Chronicle* of Theophanes the

3. The beginnings of the image struggle

Confessor, where 'the populace of the imperial city ... killed a few of the emperor's men who had taken down the Lord's image that was above the great bronze [*chalke*] gate, with the result that many of them were punished in the cause of the true faith by mutilation, lashes, banishment, and fines, especially those who were prominent by birth and culture'.

The similarity between these two accounts is clear, but so too is a significant difference: rather than the women of the *Life* of St Stephen, Theophanes, an aristocratic monk, cast the powerful – men like himself – in the role of the pro-image heroes. We are not dealing with straightforward reporting, but with constructions of opposition, designed to make the same point to diverse audiences by casting different groups in the role of innocent victims. The extent to which either of these versions is grounded in actual events is impossible to say, but there are certainly no accounts written during Leo's own lifetime that support the stories told by Theophanes or the author of Stephen's *Life* shortly after the year 800.

We are left, then, with no clear indication of Leo III's beliefs, save that around 730 Germanos held him up as a friend of images; and that in the early ninth century he was the villain of a legend about the beginning of the image struggle. On this basis, we can hardly reconstruct the early years of iconomachy as an imperial movement. This was, however, to change under Leo III's son, Constantine V.

References

Germanos' letters are published (in Greek) in Mansi xiii, 100A11–105A3 and PG 98:156B12–161C5 (letter to John); Mansi xiii, 105B7–E11 and PG 98:161D6–164C10 (letter to Constantine); Mansi xiii, 108A7–128A12 and PG 98, 164D3–188B12 (letter to Thomas). A detailed German summary and commentary appears in D. Stein, *Der Beginn des byzantinischen Bilderstreites und seine Entwicklung bis in die 40er Jahre des 8. Jahrhunderts*, Miscellanea Byzantina Monacensia 25 (Munich, 1980) 5–23 (letter to John), 23–30 (letter to Constantine), 30–82 (letter to Thomas). For full discussion in English, see Brubaker and Haldon, *Byzantium in the Iconoclast Era: a history* (as in Chapter 1), 94–105.

References to Leo III in the **Book of the Popes** may be found in L. Duchesne (ed.), *Liber Pontificalis: texte, introduction et commentaire*, 2

vols, Bibliothèque des Écoles Françaises d'Athènes et de Rome, II sér., 3 (Paris, 1886/92; repr. 1955) I, 403-4, 415-16, 476-7. For an English translation see R. Davis, *The Lives of the Eighth-century Popes (Liber Pontificalis)* (Liverpool, 1992). Demonstrations that these are later insertions have been published by J. Gouillard, 'Aux origines de l'iconoclasme: le témoignage de Grégoire II?', *Travaux et Mémoires* 3 (1968), 243-307, esp. 277-97, 299-305; P. Schreiner, 'Der byzantinische Bilderstreit: kritische Analyse der zeitgenössischen Meinungen und das Urteil der Nachwelt bis Heute', *Bizanzio, Roma e l'Italia nell'alto medioevo* I, Settimane 34 (Spoleto, 1988), 319-407, esp. 370-1; P. Speck, *Ich bin's nicht, Kaiser Konstantin ist es gewesen. Die Legenden vom Enfluß des Teufels, des Juden und des Moslem auf den Ikonoklasmus*, Poikila Byzantina 10 (Bonn, 1990), 637-95.

For **Byzantine accounts of the 717/8 siege**, see Theophanes' *Chronicle*: C. de Boor (ed.), *Theophanis Chronographia*, 2 vols (Leipzig, 1883, 1885), 395-8, English tr. C. Mango and R. Scott, *The Chronicle of Theophanes Confessor* (Oxford, 1997), 545-6; and Nikephoros' *Brief History*, 53-4: *Nicephorus, Patriarch of Constantinople: Short History*, text, tr. and commentary by C. Mango (Washington DC, 1990), 120-4.

For the **story of the Chalke gate** in the *Life* of Stephen the Younger, see M.-F. Auzépy, *La Vie d'Étienne le Jeune par Étienne le Diacre*, Birmingham Byzantine and Ottoman Monographs 3 (Aldershot, 1997), 100-1, French tr. 193-4; for the version in Theophanes, see his *Chronicle* (as above), 405; English tr. Mango and Scott (as above), 559-60.

Bibliography

The standard reference works (cited in the Bibliography to Chapter 1) present a different picture of Leo III and iconomachy, but provide excellent overviews of other aspects of his career. See also S. Gero, *Byzantine Iconoclasm during the Reign of Leo III, with particular attention to the oriental sources*, Corpus Scriptorum Christianorum Orientalium 346, Subsidia 41 (Louvain, 1973).

On the **military situation** during the reign of Leo III see, for the **Bulgars**, F. Curta, *Southeastern Europe in the Middle Ages 500-1250* (Cambridge, 2006) and, for the **Arabs**, R.-J. Lilie, *Die byzantinische*

3. The beginnings of the image struggle

Reaktion auf die Ausbreitung der Araber, Miscellanea Byzantina Monacensia 22 (Munich, 1976).

On Leo III's **rise to power** see W.E. Kaegi, *Byzantine Military Unrest 471-843: an interpretation* (Amsterdam, 1981), 192-4.

On **'Greek fire'** see J. Haldon, 'Greek fire revisited: recent and current research', in E. Jeffreys (ed.), *Byzantine Style, Religion and Civilization: in honour of Sir Steven Runciman* (Cambridge 2006), 290-325.

On the *Ekloge* see L. Burgmann (ed.), *Ecloga. Das Gesetzbuch Leons III. und Konstaninos' V.*, Forschungen zur byzantinischen Rechtsgeschichte 10, Frankfurt a. M., 1983), with discussion of the dating at 10-12.

On the Byzantines as **God's chosen people**, see S. MacCormack, 'Christ and empire, time and ceremonial in sixth-century Byzantium and beyond', *Byzantion* 52 (1982) 287-309 and F. Dvornik, *Early Christian and Byzantine Political Philosophy*, 2 vols (Washington DC, 1966), esp. 2, 797, 823.

For further discussion of the **Chalke gate legend**, see M.-F. Auzépy, 'La destruction de l'icône du Christ de la Chalcé de Léon III: propagande ou réalité?', *Byzantion* 40 (1990), 445-92; repr. in *eadem*, *L'histoire des iconoclastes* (Paris, 2007), 145-78; and L. Brubaker, 'The Chalke gate, the construction of the past, and the Trier ivory', *Byzantine and Modern Greek Studies* 23 (1999), 258-85.

4

Constantine V, the 754 synod, and the imposition of an official anti-image policy

Leo III's son and co-ruler, Constantine V (sole rule 741-775), was challenged for the throne at his father's death by his brother-in-law, his father's former ally the general Artabasdos, but cemented his position in Constantinople by 743. He had to besiege the capital in order to achieve this, however, which caused a severe famine. This was followed in 747 by the last outbreak of plague in Byzantium until the Black Death in 1347, which, according to the monk Theodore of Stoudios, left the city deserted. In the aftermath of these disasters – and the damage resulting from an earthquake that had damaged the capital in 740 – Constantine repopulated the city by relocating people from the Aegean islands, Hellas and the Peloponnese into Constantinople, and initiated major repairs to the urban infrastructure.

The 740s were clearly traumatic. Perhaps as a result, Constantine V seems to have thought long and carefully about his own theological position. He evidently concluded that the iconoclasts – who had, as we saw in the last chapter, been active in the environs of Constantinople since the 730s – were thinking along the right lines, and around 750 he wrote and delivered his *Questions* (*Peuseis*), perhaps to a group of churchmen. The text survives only in fragments, quoted to refute them by a later patriarch of Constantinople, Nikephoros (806-815); but the main lines of Constantine's beliefs are clear. In the first *Question*, the emperor argued that Christ's two natures, human and divine, could not be separated; only the human Christ, however, could be represented: portraits of Christ thus heretically divided his two natures. The second *Question* maintained that only the eucharist (holy communion), not

4. Constantine V, the 754 synod, and the anti-image policy

paintings, presented the real image of Christ, because, when consecrated, the bread and wine represented his body and blood. According to several sources, Constantine hosted meetings at which he attempted (successfully, in the end, as one would expect from an emperor) to persuade others of his point of view.

The iconoclast synod of 754

Constantine V thus appears as an iconoclast in the late 740s or early 750s. In 754, he called a church synod to make this policy official. Held in the imperial palace at Hiereia, 338 bishops attended, mostly from the Constantinopolitan area but also from Italy, Dalmatia, Hellas and Sicily. Normally, the patriarch presided over church councils, but the patriarch Anastasios had died shortly before the synod met and a new patriarch was not elected until the final session of the council in August. Hence, Theodosios, metropolitan (archbishop) of Ephesos, presided. Theodosios' relations with Constantine V are never spelled out in the sources, but he seems to have been under the emperor's thumb: certainly the *Horos* ('definition') that the synod drew up follows Constantine's thoughts, as we know them from the *Questions*, closely. The *Acts* of the synod do not survive, but the main points can be reconstructed from the *Horos* and from the writings of those who later condemned it.

According to the 754 synod, Christ, the Virgin and the saints could not be represented in images for two distinct reasons. First, portraits of Christ would separate his human from his divine nature; and, secondly, portraits of the Virgin and saints insulted their memories, for they lived eternally beside God. Instead, as Constantine V had already argued, the eucharist was the only true image of the divine dispensation which is Christ. It was, however, forbidden to tamper with liturgical vessels, altar cloths or hangings bearing images, without special permission from the patriarch and the emperor, 'lest under this pretext the devil dishonour God's churches'.

The synod rejected the devotion shown to images, and their display, either in churches or in private houses. The Hiereia churchmen represented themselves as upholding the tradition of the church, in contrast to the false and innovative doctrines of their opponents. On this latter point – a reference to the novelty of the role of images as channels

to the real presence of saints – they were more or less correct, as we have seen. What the churchmen did not say (though they were later accused of having done so) is also important to note: the synod did not reject the honouring of the Virgin, or the saints and their relics, and indeed it emphasised the honour due to the Virgin.

The 754 synod shaped a theology focused on the Trinity, including the holy spirit (which transmitted holiness to the bread of the eucharist, thus making the eucharist a true image of Christ). And, according to the synod, the only religious symbol of importance was the cross, which recalled Christ's crucifixion and had represented the God-protected and victorious emperors from the time of Constantine I the Great, the fourth-century founder of Constantinople. There were three major spin-offs of these beliefs. The first responded to the strong emphasis on the eucharist and the hierarchy of holiness evident in the synod's thinking: Christian altars, the sites where the eucharist was celebrated, were to be dedicated exclusively to the Trinity, and so relics were to be removed from them to avoid contamination of the Trinity by the bodily remains of mortal saints. Second, the anxiety to avoid contamination and to ensure purity by making a clear distinction between the sacred (spiritual) and the profane (material) was also made evident in a decree that the intercessory power of saints was reached through prayer, rather than through their relics or their portraits. Third and finally, the symbolic resonance of the cross as a victorious standard closely associated with the imperial house became increasingly important, and took on complementary force as an emblem of Christian opposition to Islam. Decorating churches with images of crosses should not, however, be seen as a radical iconoclast innovation: the motif was thoroughly familiar, and the surviving sixth-century ornament at Hagia Sophia consists exclusively of crosses and other non-representational motifs.

Another major characteristic of the synod's *Horos* was its emphasis on the importance of the church as an institution. This appears in a number of forms, all of which make clear the churchmen's desire to take control of spiritual leadership – to remove people's personal relationship with saints, channelled through relics and icons, and instead to insist that people used the clergy as their intermediaries. In other words, the synod wanted to move from a bottom-up theology, in which priests were not necessarily the central figures (though this was not at all what the

4. Constantine V, the 754 synod, and the anti-image policy

Quinisext council intended, it is evidently what the Hiereia churchmen feared), to a top-down theology, in which the church controlled people's access to the sacred. Hence the council rejected all sources of spiritual authority outside the church (including, as we have seen, images as sites of the 'real presence' of saints) and decreed that the clergy were the only authoritative intermediaries between the sacred and humanity. As a corollary to the rejection of images and the promotion of the clergy, the synod stressed the importance of the spoken or chanted word, in other words the liturgy.

The destruction – and construction – of images

Had the emperor wished to mount a concerted assault on images, it would surely have been not long after the 754 synod had ratified his personal beliefs as the official view of the state, yet there is little evidence for any actual destruction. As we have seen, the *Horos* specifically forbade acts of vandalism against ecclesiastical furnishings. Furthermore, the later claims of the pro-image faction that their enemies set about destroying images rest on a very few events, almost all of dubious authenticity. The only surviving evidence of deliberate iconoclast activity in the capital appears in the *sekreton* (council hall) that linked the patriarchal palace with Hagia Sophia. Here crosses replaced busts of saints (Fig. 4), and their identifying inscriptions were picked out (though their location is evident from the disruption of the mosaic cubes). The alteration has been associated with renovations commissioned by the iconoclast patriarch Niketas (766-780) sometime between 766 and 769. This is a good twelve to fifteen years after the 754 synod rejected images, and the substitution seems only to have been undertaken when other renovations were being made. Whatever Constantine's feelings, the evidence suggests that he implemented his policies only when a naturally-arising opportunity made it possible

The only other preserved example of iconoclast activity was the replacement of a mosaic portrait of the Virgin and child with a cross in the now-destroyed monastic church of the Koimesis (Dormition) of the Virgin at Nikaia (Fig. 5). The original image, probably of the Virgin and child, was replaced by a cross, the faint outlines of which were still visible until the church was burned down in 1922, and are still visible in

Fig. 4. Constantinople, Hagia Sophia, *sekreton*: iconoclast cross.

photographs taken before the fire. The cross was, in turn, replaced by another image of the Virgin and child, probably in the eleventh century. Exactly when the cross was inserted is not clear, but it is probably safe to assume that it was during the reign of either Constantine V or the only other 'active' iconoclast emperor, Theophilos (829-842).

Later sources accuse the iconoclasts of destroying many other images.

4. Constantine V, the 754 synod, and the anti-image policy

Fig. 5. Nikaia, Koimesis church, apse mosaic (now destroyed).

The most credible claim appears in a ninth-century (?) miracle story. Elias, priest at Hagia Sophia, wrote a history of the church of the Virgin of the Chalkoprateia (coppermarket), which he says was decorated with a mural cycle of the life of Christ. He tells us that Constantine V removed the apse mosaic and replaced the image with a cross; the iconophile patriarch Tarasios (784-806), still according to Elias, then took out the cross, and restored the images of Christ and his mother as they had been before. A miracle, which inspired Elias' story, occurred shortly thereafter.

The Chalkoprateia was a major cult centre, housing an important relic of the Virgin, her belt; it was the focus of numerous processions, and the feast of the Annunciation (25 March) was sometimes celebrated there. The church was part of the ecclesiastical and imperial heart of Constantinople, under the jurisdiction of Hagia Sophia (which is why Elias wrote about it) and was clearly sufficiently significant to be the focus of contestation. It is thus possible that the church of the Virgin of the Chalkoprateia underwent a series of transformations similar to those for which we have visual evidence at Nikaia (Fig. 5).

Other textual 'evidence' is less plausible. The *Life* of Stephen the Younger is our major source for Constantine V's purported destruction of religious imagery; but here the undeniable aim of the text to blacken the reputation of Constantine V leads its author to rhetorical excesses that are simply not credible. According to the *Life*, Constantine replaced the Christian frescoes in the church at the palace of Blachernai with secular scenes before 754. Nikephoros, a far more reliable source, noted only that an icon of the Virgin was covered over, and this version appears to receive independent corroboration in the eleventh century from John Skylitzes, who says that the image was uncovered, undamaged, in 1031. Constantine may well have ordered that an icon be covered (presumably by whitewashing) in the lead-up to the 754 synod, and 'editing' an image, in this case by covering it, also fits the evidence of the *Horos*, which as we have seen specifically condemned the destruction of church fittings.

Equally unlikely is the *Life*'s assertion that a 'satanic horse race' and a portrait of a charioteer were painted over depictions of the six Ecumenical Councils on the Milion, the massive gate in front of Hagia Sophia from which all distances in the empire were measured. There are two problems with this account. First, the text borrows heavily from an early eighth-

4. Constantine V, the 754 synod, and the anti-image policy

century account of the emperor Philippikos' removal of the image of the sixth council from the Milion (a council to which Philippikos was opposed). Second, Constantine and the 754 synod expressly identified with the tradition of the earlier ecumenical councils, in which emperors mostly played central roles. Effacing the images of earlier councils makes little sense in this context, for such an act would have been seen as a heretical attempt to overturn the canons of earlier councils. This is, evidently, precisely the brush with which Stephen's biographer was attempting to tar Constantine V, but it is extremely unlikely that the emperor would have cast himself in this role.

It is, finally, worth noting here that both pre-iconoclast imagery that survives until today (for example, at Hagios Demetrios in Thessaloniki) and textual references to icons indicate that much religious representation came through Constantine V's reign unscathed.

Artisanal production under Constantine V: From the evidence of later texts, one would think that Constantine V's reign was characterised by destruction. But, just as those accounts were greatly exaggerated, or even invented, so were Constantine's actual commissions mostly ignored by the partisan authors whose histories of the period have come down to us. In fact, Constantine V's building programme in Constantinople was extensive and important. He engaged in widespread urban renewal with the restoration of the walls and water system; he introduced new structural and decorative systems in the reconstruction of Hagia Eirene (the church of Holy Peace); and the products of his reign provide clear evidence of continuous, high-quality artisanal practice. Were it not for his iconoclast policies, to which the (iconophile) historians whose chronicles and histories have survived responded with near universal condemnation, Constantine V would now be celebrated alongside the ninth-century emperor Basil I (867-886) as the restorer of Constantinople after the so-called Dark Ages of the seventh and early eighth centuries.

The sixth-century church of Hagia Eirene in Constantinople had been severely damaged in the 740 earthquake, and was rebuilt by Constantine's masons. Wood recovered from the rebuilding has been dated to 753, based on dendrochronology (comparative wood ring analysis). Since normal Byzantine practice was to build with recently felled wood, the reconstruction of Hagia Eirene may thus be dated with some confidence

Fig. 6. Constantinople, Hagia Eirene, interior with view toward apse.

4. Constantine V, the 754 synod, and the anti-image policy

to the mid- to late 750s. The eighth-century structure retained the scale and plan of the original church, but introduced a novel vaulting system to support a large new dome that was second in size only to that at Hagia Sophia. The apse mosaic follows iconoclast tradition and shows a cross. But however normative the motif, the mosaic is technically innovative and set standards followed for the next century. The cross is outlined in black, and set against a ground composed of small, closely set glass cubes glazed with gold leaf, into which cubes glazed with silver are randomly inserted (Fig. 6). Hagia Eirene preserves the oldest known example of this formula, introduced in order to soften and lighten the impact of the gold background. The mosaic is also distinguished by its use of visual compensation. The cross arms are not straight, but curve downward: the mosaicist counteracted the curve of the apse in order to make the arms of the cross appear horizontal from the ground. This was an expensive mosaic, using far more gold and silver than was necessary in its densely packed glass cubes, and is of exceptionally high technical quality.

A decade later, Hagia Sophia and the neighbouring patriarchal palace were also repaired, this time under the auspices of the patriarch Niketas, who, we are told fifteen or twenty years later by Nikephoros, 'restored certain structures of the cathedral church that had fallen into decay with time' in 768/9. As we have seen, it was during this restoration that crosses were substituted for portraits of saints (Fig. 4).

A handful of other churches are noted in various sources but no longer survive. Textual evidence suggests that the Hodegon chapel near the sea walls in the capital – later a well-known cult site dedicated to the Virgin, which by the ninth century housed a portrait of Mary said to have been painted by St Luke the evangelist – was expanded and given monastic status under the auspices of Constantine V. The emperor's involvement with the double monastery of the abbess Anthusa at Mantineon in Paphlagonia is also mentioned in several sources. The complex was apparently constructed around 740, and included two large churches, one dedicated to the Theotokos (for the nuns), the other to the Holy Apostles (for the monks). We are told in various (tenth-century) sources that Anthusa was staunchly pro-image, and refused to recant even under torture – from which she survived unscathed. Constantine V is then said to have visited the monastery to question Anthusa, who predicted that the empress, then enduring a difficult pregnancy, would give birth to a

boy and a girl. In response, the empress gave villages and donations to the monastery, and Constantine V 'desisted from his hostile intentions'. We are later told that the couple named their daughter Anthusa, presumably after the abbess who foretold her birth.

Whatever the truth value of this story, the Mantineon episode adds significantly to our understanding of material culture during the eighth century. First, with Hagia Eirene, it provides another example of large-scale ecclesiastical building in the middle of the eighth century. Second, it supplies the first of many demonstrations that monasteries continued to prosper in a period that has sometimes been viewed as hostile to them. And in this connection, it might also be noted that there are a number of other monasteries known from textual evidence to have been built during Constantine V's reign, but without imperial assistance, notably the monasteries associated with Stephen the Younger.

In addition to monumental building, at least one illustrated manuscript is preserved from the period of Constantine V. This is an illustrated copy of Ptolemy's tables for computing the date of Easter, now in the Vatican Library, which was produced in Constantinople in the 750s. The manuscript includes paintings of all signs of the zodiac spread, three per side, across thirty-two pages, along with three full-page miniatures. These show the constellations of the northern (Fig. 7) and southern hemispheres, and a 'sun-table', with personifications of the hours, the months, and the signs of the zodiac in concentric circles around a personification of the sun (Helios) in a chariot (Fig. 8). The Ptolemy illustrations are an important witness to Byzantine interest in accurate scientific information in the eighth century – the tables, for example, were calculated to be accurate from the latitude of the capital, and the sun table indicates the precise time that the sun enters each zodiacal house – and are also our best evidence of painting in Constantinople in the eighth century. Throughout the manuscript, the painters used a wide range of colours, including the most expensive, gold and blue. Figures and animals are carefully modelled, and meticulously executed; the night sky (Fig. 7) is a technical tour-de-force. Like the apse mosaic at Hagia Eirene, the miniatures of the Vatican Ptolemy demonstrate that high quality, innovative artisanal production continued during the reign of Constantine V. Rather than condemned for its destruction,

4. Constantine V, the 754 synod, and the anti-image policy

Fig. 7. Vat. gr. 1291, fol. 2v: constellations of the northern hemisphere.

Fig. 8. Vat. gr. 1291, fol. 9r: sun table.

4. Constantine V, the 754 synod, and the anti-image policy

Constantine's reign should be remembered as one of construction and technological innovation.

Byzantium and its neighbours

We are so accustomed to thinking about the eighth century in Byzantium only in terms of the image struggle that Constantine V's other achievements are often forgotten. His reign saw, however, major shifts in international policy, most of which had little to do with his beliefs about religious images. They are nonetheless important for us to consider, however briefly, as part of a reassessment of Constantine V; and Byzantium's discussions with the Franks and the pope about images are, of course, directly pertinent to the topic of this book.

The stabilisation of Byzantine frontiers: One of Constantine V's most significant long-term achievements was the stabilisation of the empire's borders with Bulgaria and with the Islamic caliphate. Constantine's major accomplishment here was the development of an unpopulated buffer zone along the Arab frontier, which discouraged raiding parties and, by making hostile forces venturing into this zone more visible, also made them easier to detect and track. In the mid-750s, as part of this strategy to depopulate the frontier zones bordering on Arab-held lands, Constantine relocated emigrants from north Syria and the Anatolian region into Thrace and built a chain of fortresses to protect them against the Bulgars. In response, the Bulgars demanded renewed payments from the emperor; when these were refused, a Bulgar army marched into Thrace. Constantine's troops beat them back and, across the next twenty years, mounted nine further campaigns against them. By the end of his reign in 775, the western frontier was stabilised, and Byzantium once again controlled the south and central Balkans.

Constantine's strategy of reducing tensions on the Arab frontier by creating a buffer zone between Byzantine and Arab territory was helped by internal problems within the Umayyad caliphate, which faced a Berber revolt in North Africa in the early 740s and in 744-746 a civil war. This ultimately led to the downfall of the Umayyads in 749/50 and the victory of the 'Abbasids, who transferred the caliphate's capital from Damascus to Baghdad; the Islamic centre of power – and caliphal preoccupations – thus

moved much further from the Byzantine heartland. For both of these reasons, during Constantine's reign the Byzantine-Islamic frontier was stabilised and remained so (more or less) for the next two hundred years.

Maintaining peace on the eastern and western fronts required effective military and diplomatic skills, and both were expensive. To optimise efficiency, Constantine V reformed the military administration. He also created a centrally-paid and controlled palatine army, which remained loyal to the emperor long after his death, as we shall see.

Byzantium and the West: Constantine was, however, apparently much less interested in his far western provinces, for in 751, Byzantium lost its remaining territories in north Italy (except Venice) to the Lombards and, most important of all, Calabria and Sicily in the south. Diplomatic ties between Constantinople and the West nonetheless remained strong. For example, pope Zacharias (741-752) sent his legates to Constantinople after his election; and after Pippin became king of the Franks in 751, a Byzantine embassy in 757 conveyed gifts to him including an organ and silks. For much of Constantine's reign, alliances across the Italian peninsula shifted opportunistically between various pairings of the major players – the Franks in Francia (now France and western Germany) and eventually northern Italy, the Lombards in northern and central Italy, the pope in Rome, and the Byzantines in southern Italy and the East. By the time of Constantine V's death, however, the popes had turned more or less permanently from relying on Constantinople to relying on the Franks (and their successors) for aid and protection. This was largely due to the increasing local strength of the Franks and above all the increasing danger to Rome of the Lombards, but also – though to a lesser extent – to differences in religious policy.

The western response to the Council of 754: The letters of pope Paul I (757-67) to king Pippin emphasise the efforts he had made to persuade Constantine V that he was wrong to ban religious imagery, and his influence may explain Pippin's refusal to consider a marriage between his daughter Gisela and Constantine V's son Leo IV. But this is Paul's only reference to Constantine's beliefs – on the whole, relations with Constantinople during his papacy were dominated by Italian political concerns.

4. Constantine V, the 754 synod, and the anti-image policy

Under popes Paul I and Stephen III (768-772), however, two synods – one at Gentilly in Francia in 767, the other at the Lateran in Rome in 769 – condemned Constantine V's image policy. The *Acts* of the Gentilly meeting do not survive, but Roman and Byzantine theologians are reported to have debated the issue of holy images before the Frankish king, and to have rejected Constantine V's position. We know much more clearly what was actually agreed at the 769 Lateran synod, the *Acts* from which are preserved. This synod was prompted by the arrival of a letter to the pope from the eastern patriarchs (representing those Christians now living in lands under Arab rule) that set out their disagreement with the church at Constantinople over the question of images, and enlisted the support of Rome. The synod duly condemned the synod of Hiereia (this is the first explicit reference to the 'official' and imperial nature of the anti-image legislation in Byzantium in western sources). Henceforth, pope Stephen III intensified papal ties with the Franks and loosened those with the empire. Constantine V's only remaining ally in northern Italy was Desiderius, king of the Lombards, who was conquered by Charlemagne in 773/4.

Constantine V and the monasteries: persecution or a response to treason?

Later sources and much modern scholarship insist that the reign of Constantine V was marked by persecution of monks and monasteries, which were – it is claimed – the bastions of the pro-image defence. In fact, evidence for any serious persecution of individuals is sparse and attached less to religious difference than to state treason. And, though it has often been assumed that the persecution (such as it was) of monks and monasteries under Constantine V was bound up with iconomachy, there is no evidence – other than the assertions in later anti-iconoclast texts such as the *Life* of Stephen the Younger – that images were the driving force. Furthermore, except for the execution of a monk called Andreas (or Peter, depending on which text one reads) in 761/2 for treason, Constantine V's irritation with monks appears to have been relatively short-lived, beginning in 765/6 and ending about 772/3.

The *Life* of Stephen the Younger, which dates from the first decade of the ninth century as we have already seen, is the major source for

Constantine V's supposed antipathy toward monks and monasticism. But the *Life* is not a historical account of the realities of Stephen's life. As Marie-France Auzépy has demonstrated, it was constructed as a propaganda piece to promote the role of the monastic community as supporters of images (a role that was effectively invented in the early ninth century, when the *Life* was written), and to slander the Isaurian emperors (Leo III and the dynasty he founded). And even here, in a text with many agendas beyond historical reporting, Constantine is said to have put a great deal of effort in attempting to win Stephen over to his own point of view: only when all his efforts had failed did he go ahead with Stephen's execution. Theophanes, who championed Stephen, nonetheless hints at the real reason for the death sentence by noting Stephen's connection with a cadre of court dignitaries executed for treason – though Theophanes, as one would expect, claimed that all were 'falsely accused' because Constantine V 'bore them a grudge because they were handsome and strong and praised by everyone'.

The nature of the treasonous plot is unclear. In addition to Stephen the Younger, the patriarch Constantine and nineteen court officials were implicated. All were either punished or killed, which suggests that the scheme was not a minor infraction but a serious conspiracy. Whatever it entailed, the discovery of the 765/6 plot led to a purging of Constantine V's opponents that lasted until 772/3. This included attacks on some monastic establishments, but it cannot be said that Constantine V was against monks and monasticism in general: as we have already seen, Constantine also built or endowed monasteries; several monks were his close associates; and it was the monks in the palace who are claimed by Theophanes to have identified the patriarch Constantine as part of the 765/6 conspiracy. Nor, indeed, were all monks in favour of icons – many, according to the pro-image monk Theodore of Stoudios, adhered to the iconoclast policy set forth in 754.

Despite this, the later sources most hostile to Constantine V – in particular, Theophanes and the author of the *Life* of Stephen the Younger – present a vivid picture of monastic degradation. They tell us that monks and nuns were forced to parade hand in hand in the hippodrome, to the amusement of the crowd; this same group was, we are told, to be shunned and referred to as 'unmentionables'. Theophanes is also our main source for Michael Lachanodrakon, general in the *Thrakesion* district, who is

4. Constantine V, the 754 synod, and the anti-image policy

supposed to have closed and sold off the monasteries in his jurisdiction, punishing and slaying many of their inhabitants. These stories have been shown to be exaggerated, or simply invented, but Lachanodrakon was a loyal and trusted general under Constantine V (and continued to be, under both the anti-image Leo IV and the pro-image Constantine VI, even after the 787 council restored icon veneration), and so may have played a role in whatever imperial sanctions against selected monasteries were enforced.

But while later accounts of monastic harassment and much modern scholarship claim a connection between monks and icons, there is little evidence of this. Though the emphasis on the clergy as the sole mediator of divine authority superseded any role monks and nuns may have hoped to play as alternative sources of spiritual authority, the *Horos* of 754 in fact praised them as 'living images' whose deeds and lifestyle were to be imitated, an attitude reflected in saints' lives written by iconoclast sympathisers. Monks and monasteries implicated in the 765/6 plot and its aftermath were, not surprisingly, punished; Constantine V's critical reaction to some monks was, however, later recast as an attack on all monks, and (wrongly) associated solely with his image policy.

Conclusions

The massive urban renewal initiated by Constantine V played into what may have been a conscious effort to promote the emperor as the second founder of Constantinople, following in the footsteps of Constantine I. As Paul Magdalino has observed, the 754 synod 'acclaimed him as "New Constantine", the equal of the apostles, who had abolished idolatry'. Yet Constantine V is not normally remembered in such a positive light. As the only eighth-century emperor publicly and vigorously to support an anti-image religious policy, Constantine became the focus of attack after this policy was overturned in 787, and again after the final restoration of images in 843. For example, Theophanes, in his *Chronicle* of *c.* 810, accuses Constantine of speaking against devotion to the Virgin. As we have seen, however, Constantine's *Peuseis* promotes the Virgin, and this passage in Theophanes thus seems to be a deliberate (and defamatory) recasting of Constantine's attempt to ensure that oaths in the name of the Virgin were not diluted by overuse. Though even his later Byzantine

detractors admitted his qualities as a strong military leader and as the reconstructor of the urban fabric of Constantinople, they created a damning portrait of activities associated with his religious policies such as his purported persecution of monks and destruction of church decorations and furnishings. As we have seen, most of this cannot be substantiated. Contemporary texts are silent, and there was no protest from Rome: the entry for pope Stephen II (752-7) in the *Book of the Popes* did not mention the 754 synod, or refer to the icon debates at all. Constantine V has fallen victim to an extremely successful later smear campaign – and the negative image promoted by later Byzantine authors has been accepted uncritically by most modern scholars until now.

References

For the ***Horos*** of the 754 Council (p. 33) see Mansi xiii, 205-365; for an English tr., see C. Mango, *The Art of the Byzantine Empire 312-1453* (Englewood Cliffs NJ, 1972), 165-9; S. Gero, *Byzantine Iconoclasm during the Reign of Constantine V, with particular attention to the oriental sources*, Corpus Scriptorum Christianorum Orientalium 384, Subsidia 52 (Louvain, 1977), 68-94; D.J. Sahas, *Icon and Logos: sources in eighth-century iconoclasm* (Toronto, 1986).

For **Theophanes on Constantine's beliefs about relics** (p. 33), see his *Chronicle* (as in Chapter 3), 439, 442, English tr. Mango and Scott (as in Chapter 3), 607, 610. There is an excellent discussion in M.-F. Auzépy, 'Les Isauriens et l'espace sacré: l'église et les reliques', in M. Kaplan (ed.), *Le sacré et son inscription dans l'espace à Byzance et en occident, etudes comparées*, Byzantina Sorbonensia 18 (Paris, 2001), 13-24; repr. in eadem, *L'histoire des iconoclastes* (Paris, 2007), 341-52.

For **Elias' miracle story about the Chalkoprateia** (p. 38), see W. Lackner, 'Ein byzantinisches Marienmirakel', *Byzantina* 13 (1985), 835-60, esp. 856-7.

On Constantine's 'destruction' of images at **Blachernai** (p. 38), see the *Life* of Stephen the Younger: Auzépy, *La Vie d'Étienne le Jeune par Étienne le Diacre* (as in Chapter 3), 126-7, French tr. 221-2; English tr. in Mango, *Art of the Byzantine Empire* (as above), 152-3. Gero, *Byzantine Iconoclasm during the Reign of Constantine V* (as above), 112-13 – among others – is sceptical. For Nikephoros and Skylitzes, see *ibid.*, 112 n. 5.

4. Constantine V, the 754 synod, and the anti-image policy

On the **Milion images** (p. 38), see the *Life* of Stephen the Younger: Auzépy, *La Vie d'Étienne le Jeune par Étienne le Diacre* (as in Chapter 3), 166, French tr. 264-5; English tr. Mango, *Art of the Byzantine Empire* (as above), 153. For the problems with this account see Gero, *Byzantine Iconoclasm during the Reign of Constantine V* (as above), 113-14.

Pope **Paul's letters to Pippin** (p. 46) are preserved in the *Codex Carolinus*, W. Grundlach (ed.), *Monumenta Germaniae Historica* (*Epistolarum*) 3 (Berlin, 1957), nos 11, 25, 29, 30 and 36. See T.F.X. Noble, *The Republic of St Peter: the birth of the papal state 680-825* (Philadelphia PA, 1984), 103-12; idem, *Images, Iconoclasm and the Carolingians* (Philadelphia PA, 2009), 124; D.H. Miller, 'Papal-Lombard relations during the pontificate of Paul I: the attainment of an equilibrium of power in Italy, 756-767', *Catholic Historical Review* 15 (1969) 358-76.

For **Theophanes on Stephen and the plot against Constantine V**, see his *Chronicle* (as in Chapter 3), 438; English tr. in Mango and Scott (as in Chapter 3), 605 (and see 606 n. 8).

For **Theodore of Stoudios' remarks on the number of monks who conformed with the imperial policy** and the number of monasteries that accepted the official policy (p. 48) see: A. Fatouros (ed.), *Theodori Studitae Epistulae*, 2 vols, Corpus Fontium Historiae Byzantinae 31/1-2 (Vienna, 1992), 65, 112, 231.

On **Constantine V as a 'new Constantine'** (p. 49), see Mansi xiii, 225, 353 and P. Magdalino, 'The distance of the past in early medieval Byzantium (VII-X centuries)', *Ideologie e practiche del reimpiego nell'alto medioevo*, Settimane di Studio del Centro Italiano di Studi sull'Alto Medioevo 46 (Spoleto, 1999), 141-6 (quotation p. 141).

Bibliography

On the **famine and plague in Constantinople** see D. Stathakopoulos, *Famine and Pestilence in the Late Roman and Early Byzantine Empire: a systematic survey of subsistence crises and epidemics*, Birmingham Byzantine and Ottoman Monographs 9 (Aldershot, 2004), 377-8, 384-5.

On the **repopulation and reconstruction of Constantinople**, see the *Chronicle* of Theophanes (as in Chapter 3), 429, 440, English tr. Mango and Scott (as in Chapter 3), 593, 608; Nikephoros, *Short History* (as in Chapter 3), 140. For discussion, see R. Ousterhout, 'The architecture

of iconoclasm: buildings', in Brubaker and Haldon, *Byzantium in the Iconoclast Era: the sources* (as in Chapter 1), 17-19.

The refutation of **Constantine's** *Questions* appears in Nikephoros' *Antirrhetikos*, a discourse against the iconoclasts: PG 100: 205-534 (in Greek); tr. into French in M.-J. Mondzain-Baudinet, *De notre bienheureux père et archevêque de Constantinople Nicéphore discussion et réfutation des bavardages ignares, athées et tout à fait creux de l'irréligieux Mamon contre l'incarnation de Dieu et le Verbe notre sauveur. Discours contre les iconoclastes* (Paris, 1989). On the **eucharist as true image of Christ** see S. Gero, 'The eucharistic doctrine of the Byzantine iconoclasts and its sources', *Byzantinische Zeitschrift* 68 (1975), 4-22.

On the **council of 754** see Herrin, *Formation of Christendom* (as in Chapter 1), 368-70.

On the **Hagia Sophia** *sekreton* **mosaic crosses**, see R. Cormack and E. Hawkins, 'The mosaics of St Sophia at Istanbul: the rooms above the southwest vestibule and ramp', *Dumbarton Oaks Papers* 31 (1977), 204-5, 210-11, figs 14, 20-1.

On **Nikaia** see C. Barber, 'The Koimesis Church, Nicaea. The limits of representation on the eve of Iconoclasm', *Jarhbuch der Österreichischen Byzantinistik* 41 (1991), 43-60.

On the church of the Virgin of the **Chalkoprateia**, see C. Mango, 'The Chalkoprateia Annunciation and the pre-eternal Logos', *Deltion tes christianikes archaiologikes etaireias* IV, 17 (1993/4), 165-70.

On other **accounts of image destruction**, see L. Brubaker, 'On the margins of Byzantine iconoclasm', in P. Odorico (ed.), *Byzantina-metabyzantina : la périphérie dans le temps et l'espace*, Actes de la 6e Séance Plénière du XXe Congrès International des Études Byzantines, Dossiers Byzantins 2 (Paris, 2003), 107-17.

On **Hagia Eirene**, see W.S. George, *The Church of Saint Eirene at Constantinople* (Oxford, 1912); Brubaker and Haldon, *Byzantium in the Iconoclast Era: the sources* (as in Chapter 1), 19-20. On the **cross in anti-Muslim polemic**, see K. Corrigan, *Visual Polemics in the Ninth-century Byzantine Psalters* (Cambridge, 1992), 91-4; and **in Hagia Sophia**, see Gero, *Byzantine Iconoclasm during the Reign of Constantine V* (as above), 162-4; R. Cormack, 'The emperor at St Sophia: viewer and viewed', in A. Guillou and J. Durand (eds), *Byzance et les images* (Paris, 1994), 235-6.

On the **Hodegon** monastery, see C. Angelidi, 'Un texte patriograpique

4. Constantine V, the 754 synod, and the anti-image policy

et édifiant: le "discours narratif" sur les Hodègoi', *Revue des Études Byzantines* 52 (1994), 113-49.

On the monastery of **Anthusa**, see C. Mango, 'St Anthusa of Mantineon and the family of Constantine V', *Analecta Bollandiana* 100 (1982), 401-9.

On **Stephen the Younger's monasteries**, see R. Janin, *Les églises et les monastères des grands centres byzantins* (Paris, 1975), 45-7.

On the **Vatican Ptolemy** (Vat.gr. 1291), see D.H. Wright, 'The date of the Vatican illuminated handy tables of Ptolemy and of its early additions', *Byzantinische Zeitschrift* 78 (1985), 355-62 and Brubaker and Haldon, *Byzantium in the Iconoclast Era: the sources* (as in Chapter 1), 38-9; and on the 'scientific renaissance' during the second half of the eighth century, as exemplified by the Vatican Ptolemy and by the appointment of a court astrologer in 792, see P. Magdalino, *L'orthodoxie des astrologues: la science entre le dogme et la divination à Byzance (VIIe-XIVe siècle)* (Paris, 2006), 23-4, 50-1, 55-6.

On Byzantine relations with **Bulgaria**, see Curta, *Southeastern Europe in the Middle Ages* (as in Chapter 3), 82-90.

On **Byzantine-Islamic relations** see J. Haldon and H. Kennedy, 'The Arab-Byzantine frontier in the eighth and ninth centuries: military organisation and society in the borderlands', *Zbornik Radova Vizantoloshkog Instituta* 19 (1980), 79-116; A.D. Beihammer, *Nachrichten zum byzantinischen Urkundenwesen in arabischen Quellen (565-811)*, Poikila Byzantina 17 (Bonn, 2000).

On relations between **Byzantium, the Franks and the pope**, see Herrin, *Formation of Christendom* (as in Chapter 1), 379-81; Noble, *Images, Iconoclasm and the Carolingians* (as above), 140-5; M. McCormick, 'Byzantium and the west, 700-900', in R. McKitterick (ed.), *New Cambridge Medieval History* II (Cambridge, 1995), 349-80.

On the **Lateran synod of 769** (also known as the Roman synod): see Noble, *Images, Iconoclasm and the Carolingians* (as above), 145-9; Herrin, *Formation of Christendom* (as in Chapter 1), 393-5; and M. McCormick, 'The imperial edge: Italo-Byzantine identity, movement and integration, AD 650-950', in H. Ahrweiler and A. Laiou (eds), *Studies on the Internal Diaspora of the Byzantine Empire* (Washington DC, 1998), 47-51.

On **Gentilly**, see Noble, *Images, Iconoclasm and the Carolingians* (as above), 142-4; Herrin, *Formation of Christendom* (as in Chapter 1), 384-5.

On the **diplomatic missions of the Frankish kings**, see F.L. Ganshof, 'The Frankish monarchy and its external relations, from Pippin III to Louis the Pious', in *idem*, *The Carolingians and the Frankish Monarchy: Studies in Carolingian History*, tr. J. Sondheimer (London, 1971), 162-204; on the **gifts to Pippin** see J. Herrin, 'Constantinople, Rome and the Franks in the seventh and eighth centuries', and A. Muthesius, 'Silken diplomacy', both in J. Shepard and S. Franklin (eds), *Byzantine Diplomacy*, Papers from the 24th Spring Symposium of Byzantine Studies (London, 1992), 91-107 and 242-4.

Andreas/Peter challenged the emperor's orthodoxy: Theophanes, *Chronicle* (as in Chapter 3), 432, English tr. in Mango and Scott (as in Chapter 3), 598.

For the most recent discussion of the date, context, content and structure of **Stephen the Younger** and his *Life*, see Auzépy, *La Vie d'Étienne le Jeune par Étienne le Diacre* (as in Chapter 3) and M.-F. Auzépy, *L'hagiographie et l'iconoclasme byzantine: le cas de la Vie d'Étienne le Jeune*, Birmingham Byzantine and Ottoman Monographs 5 (Aldershot, 1999).

For the **conspiracy, Stephen's association with it**, and the **palace monks who informed on the patriarch** Constantine, see Theophanes, *Chronicle* (as in Chapter 3), 436-39, English tr. Mango and Scott (as in Chapter 3), 604-6.

On the **alienation of monastic lands**, see Theophanes, *Chronicle* (as in Chapter 3), 443, English tr. Mango and Scott (as in Chapter 3), 611. According to the *Acts* of the 787 Council (Mansi xiii, 329), several secularised monasteries were still in lay hands; canon 12 forbids the alienation of church and monastic lands henceforth and canon 13 notes that monastic properties had been sold off (*ibid.*, 431).

For hostile accounts of **Constantine V and the monks** see for example Theophanes, *Chronicle* (as in Chapter 3), 442, English tr. Mango and Scott (as in Chapter 3), 610.

On **Lachanodrakon**, see Theophanes, *Chronicle* (as in Chapter 3), 445, English tr. Mango and Scott (as in Chapter 3), 614-15 and M.-F. Auzépy, 'Constantin, Théodore et le dragon', in *Toleration and Repression in the Middle Ages: in memory of Lenos Mavrommatis*, National Hellenic Research Foundation, Institute for Byzantine Research, International Symposium 10 (Athens, 2002), 87-96.

On **monasteries and the iconoclast image of saints and monks**, see

4. Constantine V, the 754 Council, and the anti-image policy

M.-F. Auzépy, 'L'analyse littéraire et l'historien: l'exemple des vies de saints iconoclastes', *Byzantinoslavica* 53 (1992), 57-67, repr. in *eadem, L'histoire des iconoclastes* (Paris, 2007), 329-40; eadem, 'L'évolution de l'attitude face au miracle à Byzance (VIIe-IXe siècle)', *Miracles: prodiges et merveilles au moyen âge* (Paris, 1995), 31-46 ; eadem, 'Les enjeux de l'iconoclasme', *Cristianità d'occidente e cristianità d'oriente (secoli VI-XI)*, Settimane di Studio della Fondazione Centro italiano di Studi sull'Alto Medioevo 51 (Spoleto, 2004), 158-64.

On the **recasting of Constantine's actions**, see Auzépy, *L'hagiographie et l'iconoclasme byzantin* (as above), 271-88.

5

The iconophile intermission

Constantine V died in 775. One of his legacies was an emphasis on dynastic, hereditary succession, presumably in an attempt to avoid the sort of civil unrest which had characterised the empire at the time of his, and his father's, accession. Ensuring clear dynastic succession also guaranteed the security of his own family, and it plays into a widespread emphasis on family lineage across the eastern Mediterranean regions (Arab and Byzantine) in the eighth century. This legacy had long-term consequences for the Byzantine state, and its immediate impact was three-fold. First, Constantine V named the son who would succeed him after his own father (Leo III). This practice continued in the next generation too: Leo III was thus followed by Constantine V, who was followed by his son Leo IV (775-780), who, in turn, named his son Constantine VI (780-797). Second, as his father had also done, Constantine V crowned Leo IV as co-emperor in 751, shortly after his birth in 750. Following

Fig. 9. *Follis* (copper coin), class 3, of Constantine V, struck at the Constantinople mint between 751-769, with Constantine V and Leo IV on the obverse and Leo III on the reverse.

5. The iconophile intermission

Fig. 10. *Nomisma*, class 1: Leo IV and Constantine VI (obverse) and Leo III and Constantine V (reverse), 776-778.

these precedents, shortly after his own succession Leo IV crowned his eldest son co-emperor in 776, when Constantine VI was five years old. Finally, Constantine V initiated the practice of portraying the preceding emperors of the family on the reverse of his coins (Fig. 9), with himself and his son, Leo IV, on the front (obverse), and his father (Leo III) on the reverse. This too was continued by Leo IV, who duly located himself and his son, Constantine VI, on the obverse, with Leo III and Constantine V, his father and grandfather, on the reverse (Fig. 10). This new formula appeared on both the low denomination copper coins and the gold *nomismata*, ensuring broad distribution across – and beyond – the empire, thus guaranteeing widespread publicity of the dynastic concept.

Leo IV (775-780)

So far as we can tell, Leo IV did not participate actively in the image struggle. Subsequent, pro-image authors such as Theophanes described the punishment of several imperial officers during the last year of Leo's reign as the persecution of iconophiles, but this seems to have been a response to a political conspiracy against the emperor, probably initiated by his half-brothers. An even later source, the tenth-century pseudo-Symeon, claimed that Leo IV's wife Eirene was a secret supporter of icons; when Leo IV discovered two icons under her pillow, he is purported to have ceased 'marital relations' with her. This is extremely

unlikely. Eirene can hardly have been a convinced iconophile at the time of her marriage to Leo IV in 768, for it is virtually inconceivable that Constantine V would have permitted his son and heir to marry a woman whom he would have considered an idolater. More tellingly, perhaps, the tale does not appear in Theophanes' *Chronicle*, which was written only a decade after Eirene's death. Theophanes was sympathetic to the empress, and pro-icon: had he known the story of the 'secret' icons, he would scarcely have omitted it from his narrative. There is in fact no evidence until 784 – four years after Leo's death – that Eirene considered icon veneration worth supporting. Pseudo-Symeon's account is nonetheless interesting, for it exemplifies the rhetorical linkage between women and icons that we saw earlier in the *Life* of Stephen the Younger. We will return to this theme (p. 117).

Rome and the Bulgars: As we saw in Chapter 4, the Frankish king Charlemagne had conquered northern Lombard Italy in 774, at the end of Constantine V's reign. Adelchis, son of the last Lombard king Desiderius, fled to Constantinople and was awarded the rank and title of *patrikios* (patrician). Leo IV did not attempt to regain former Byzantine lands in north Italy. He did, however, repel pope Hadrian I's attempted repossession of formerly papal lands in Sicily, so it appears that Constantine V's focus on south Italy – at the expense of former Byzantine possessions in central and northern Italy – was continued.

This left a vacuum of sorts in the area around Rome, where lands formerly in imperial control seem to have been open to exploitation by others. During the first half of the eighth century, these imperial lands (sometimes referred to as 'public land' in the *Book of the Popes*) were still under the control of the emperor in Constantinople. For example, sometime around 745, Constantine V had given the imperial estates in Ninfa and Norma near Rome to pope Zacharias. But when the Lombards lost control of the former Byzantine city of Ravenna and its hinterland in 754 or 755, the imperial lands around Ravenna did not return to imperial – or even, apparently, local – control. Instead, by 782 they were clearly in the hands of the Roman church, for in that year pope Hadrian (772-795) gave some of them to the monastery of Sant Apollinare in Classe (the port of Ravenna). The same presumably happened to the imperial properties around Rome. How imperial lands became papal lands is not

clear, but it is in this context that we might understand the *Donation of Constantine*, which we first hear about in 778, in a letter from pope Hadrian to Charlemagne. This was a forgery, written sometime in the third quarter of the eighth century, which claimed that Constantine I had granted the pope a variety of imperial privileges, including the western provinces of the empire, and, of course, Rome. Why the *Donation* was written, and who its intended audience was, are both disputed. But in the years of the Isaurian emperors in Byzantium, when Rome was distancing itself from the empire and taking over political rule and imperial lands in central and northern Italy, a document claiming that a venerated earlier emperor had given the lands of Italy to the pope was certainly a well-timed 'discovery'.

At around this same time, the shift in Rome's allegiance from Byzantium to the Franks becomes apparent. Until at least 772, the papal chancery dated its texts according to the regnal years of the current Byzantine emperor. A swing away from acceptance of Byzantine authority is clear by 781, when imperial coins ceased to be minted in Rome. The break became final by 798, when the chancery shifted decisively to dating by the regnal years of the popes and the Frankish kings, omitting the Byzantine emperor entirely.

Leo IV's apparent lack of interest in central and northern Italy is at least partially due to his concentration on the Arab front, which presumably also accounted for his failure to take advantage of internal unrest in Bulgaria. In 777, khan Telerig fled to Constantinople, converted to Christianity, was given the Christian name Theophylact, and, like Adelchis, was awarded the title *patrikios*. Only at the end of his reign, however, did Leo IV move against the Bulgarians, and he died on campaign against them in 780. He was succeeded by his nine-year-old son, Constantine VI, and his widow Eirene assumed the regency. Constantine VI and Eirene's contribution to iconomachy was the restoration of images in 787.

Eirene and Constantine VI (780-797): Nikaia II and the restoration of image veneration

There is no indication that either Eirene or (still less) the young Constantine VI had any particular beliefs about the validity of image veneration before Leo IV's death, and it was only four years later, with

the installation of Tarasios as patriarch in 784, that a church council to restore the veneration of images was proposed. The empress Eirene – who, as regent, effectively ran the government – wrote to pope Hadrian in 785, telling him this, and requesting the attendance and participation of western churchmen. The first attempt to hold the council, in 786, had to be abandoned after the opening ceremonies were disrupted by bishops and soldiers loyal to the memory of Constantine V. In response, the protesting solders were sent on campaign away from the capital and troops loyal to Eirene and Constantine VI were installed in their place. The dissenting clerics were promised forgiveness, though few from Constantinople attended when the council was reconvened the following year. This may, however, have had less to do with any lingering anti-image sentiment than with local opposition to the new patriarch Tarasios, the former head of the imperial chancery (and thus well known to Eirene). The rapid promotion of a layman through the ecclesiastical ranks to qualify him for the post raised eyebrows, particularly from the monastic community, whose own favoured candidate had been rejected. But whatever the churchmen and monastic leaders of the capital thought, the council called by Tarasios – the second to be held in Nikaia and the last medieval church council to be labelled 'ecumenical' – was successfully convened in 787.

The reason given by Tarasios for the change in policy concerning icons was that the restoration of image veneration would reunify the church. Certainly it conformed with Eirene's policy of rapprochement with the pope in Rome, who, as we have seen, opposed the ban on religious images. By demonstrating renewed Byzantine solidarity with the pope, Eirene and her advisors may also have hoped – futilely, as we now know – to undercut the alliance then forming between the papacy and the Carolingians. On a more local level, Tarasios made great efforts to unify the Orthodox community. His tone throughout the council was conciliatory. From an institutional point of view, it would indeed seem that the restoration of image veneration was primarily based on a desire for ecumenical and Orthodox unity, although this, of course, ignored the different views of iconoclasts, who were numerous. The texts produced by the Nikaia Council of 787 would, however, have a lasting impact on the 'thought world' of Byzantium and on Orthodox belief.

The *Acts* of Nikaia II supply much of our information about the

5. The iconophile intermission

arguments for and against the veneration of holy portraits, and also laid the groundwork for the theology of images that continues to this day in the Orthodox church. The first three sessions were largely devoted to church discipline – including hearing renunciations of their previous iconoclast beliefs from all the churchmen present who had supported the ban on images, which was the great majority of them – and only the final three concerned the actual role of sacred portraits in the church. Sessions four and five detailed the power of images as channels to divine presence and condemned iconoclast beliefs. Session six was dedicated to the theology of image veneration, and it focussed on a renunciation and refutation of the iconoclast *Horos* of 754. The refutation was based on two points: the force of tradition and the visibility of the incarnation. The argument that the veneration of images was authorised by tradition was not strictly correct: as we have seen, this practice had become widespread only toward the end of the seventh century. That was, however, well before any of the participants in the 787 council had been born, and arguments based on the authority of tradition were so powerful in the eighth and ninth centuries that they were always invoked, usually by both sides. To modern minds, the more powerful argument concerned the incarnation. The pro-image faction argued that Christ had been seen on earth; that what can be seen can be pictured; and that to refuse to allow the portrayal of Christ was to reject his physical appearance on earth – in other words, it was to deny the incarnation, the core tenet of Christianity. The anti-icon faction was thus claimed to be guilty of a very serious heresy indeed. Finally, in the seventh session, the new *Horos* of the Council of 787 was read and signed by all those present.

The *Acts* of the 787 Council created, for the first time, the groundwork for a systematic and formal 'cult' of images. Aside from the brief restoration of the ban on images between 815 and 843, sacred portraits have ever since officially occupied a specific place in Orthodox belief, and the practices associated with the veneration of images have become an integral element of Orthodox devotion. Every Orthodox Christian was, and still is, supposed to perform *proskynesis* (bowing, kneeling or prostration) before holy images and to kiss them; and images are to be illuminated and accompanied by the burning of incense. In 787, anyone refusing to obey these prescriptions was anathematised and declared a heretic.

Responses from the western churches to the Council at Nikaia were influenced by current political affairs. We will look briefly at these, in order to set the papal and the Frankish reactions in context.

Papal and Frankish responses to the 787 Council

The political background: The restoration of unity across the Christian world was a stated aim of the 787 Council. An earlier effort to reconnect East and West had been made in 781, when a marriage between Constantine VI and Charlemagne's daughter Rothrud was agreed. Whatever fragile links had been established between the Byzantines and the Carolingian Franks did not last, however: in the end, the betrothal was called off (none of Charlemagne's daughters ever married), and Constantine VI married Maria of Amnia instead. Meanwhile, a Byzantine attempt to gain some degree of authority in the surviving Lombard parts of southern Italy failed in 788, and contact with the Frankish court appears to have been cut off for nearly a decade.

It was resumed in 797, when Constantine VI sent a messenger and a letter to Charlemagne at Aachen (the Frankish capital, founded by Charlemagne), the purpose of which remains unknown; communication continued in 798, when Eirene sent an embassy to inform the Franks of Constantine VI's death, and her accession as sole ruler. After this, Constantinople and Aachen maintained regular diplomatic contact until the end of Eirene's rule in 802. For example, a Frankish embassy arrived in Constantinople in either 801 or 802 to tell the Byzantines that Charlemagne had been crowned emperor of the West by pope Leo III at Christmas 800. It is also possible that Charlemagne proposed to marry Eirene, and re-unite the East and West Roman Empires (see below). If so, it came to nothing, and after Eirene's deposition in 802 diplomatic relations with the Franks languished until 811.

The response to Nikaia II: Pope Hadrian responded favourably to Eirene's original letter telling him of the planned council, though – inevitably – he demanded recognition of Rome's primacy and the return of papal jurisdiction over Illyricum, which had been removed from papal authority during the reign of Constantine V. Neither was forthcoming. The pope nonetheless regarded the *Acts* of the 787 Council as a clear

5. The iconophile intermission

sign that the Byzantines now recognised the errors of the iconoclast position and as a confirmation that Orthodoxy had been re-established. The Frankish theologians who examined the Latin translation sent to them were less sympathetic. In a document called *Against the Synod* (*Capitulare contra synodum*), they challenged the way in which texts had been used in support of icon veneration as an established Christian tradition, pointing out that neither the making nor the veneration of images was supported in scripture. They also challenged Eirene's right, as a woman, to convoke a church council; and they questioned the legitimacy of Tarasios' elevation to the patriarchate. *Against the Synod* no longer survives, but pope Hadrian's vehement refutation of it does. In response to the pope's rebuttal, Charlemagne ordered a detailed review of the Byzantine and papal arguments. This was compiled by the leading theologians at the Frankish court, primarily Theodulf of Orléans, and became known as the *Book of king Charles* (*Opus Caroli Regis*; it is also widely referred to as the *Libri Carolini*).

From the point of view of the theology of images, the *Opus Caroli Regis* adopts a position similar to that of the iconoclast *Horos* of 754, with the same emphasis on the Old Testament. But unlike the 754 Council, or any subsequent expression of Orthodox belief, the Carolingians argued that the prime value of religious imagery was as a text for the illiterate. In this they followed earlier papal tradition, going back to pope Gregory I the Great (590-604). According to the *Opus Caroli Regis*, and the synod of Frankfurt which followed in 794, the aim of religious imagery was to recall and to instruct. But the 'real presence' of icons was denied, and ridiculed as a recent novelty – an argument which is very close to that of the iconoclast Council of 754, as indeed was the Carolingian emphasis on the Trinity as more important than the saints.

The *Opus Caroli Regis* presents a singular argument, but its impact remained local. To the Franks, this was a relatively marginal issue, and only Theodulf and a few other intellectuals followed it up after 794. The very existence of the text, however, demonstrates that however much Eirene and Tarasios may have hoped that the 787 Council would unify the Christian church, the cultural differences and divisions between Byzantium, the papacy, and the Franks were, by now, not so easily bridged.

Byzantine responses to the 787 Council

So far as we can tell, there was no negative public reaction to the 787 Council inside the Empire. Nor was there any immediate impact on the production of religious imagery, or at least none that can now be discerned. The commissions associated directly with Eirene and Constantine VI – one, Hagia Sophia in Thessaloniki, surviving and the others known from documentary sources – are remarkably similar to works produced under Constantine V.

Hagia Sophia in Thessaloniki: Eirene's family was from Greece, and she apparently took a special interest in the region. Byzantine foreign policy was markedly successful there, and the Empire re-occupied areas that had not been under Byzantine control since the mid-seventh century. By the end of Eirene's reign in 802 imperial authority and church administration in the area had been strengthened, and a new military force was apparently established to protect the region.

Eirene and Constantine VI toured Greece in 784 and again in 786, establishing new bishoprics and reviving others. It may have been at this time that they commissioned the mosaic decoration at Hagia Sophia in Thessaloniki (Fig. 11) that carries their enjoined monograms, the only surviving architectural project associated with the imperial house during the reigns of Constantine VI and Eirene. The mosaic, which covers the vault just in front of the apse, incorporates a cruciform monogram of Eirene and Constantine VI, so must be dated to the period of their joint rule, 780-797.

The vault mosaic shows a gold cross surrounded by stars, set – like the crosses inserted in the *sekreton* at Hagia Sophia in Constantinople a few decades earlier (Fig. 4) – against concentric circles of blue, to indicate heaven. The lower third of both sides of the vault is filled by rows of small squares containing crosses and five-lobed leaves, divided by bands decorated with simulated jewels and pearls. At the base of the vault, an inscription incorporates the imperial monogram and invokes Theophilos, the bishop of Thessaloniki. The apse itself was originally decorated with a cross with – as at Hagia Eirene (Fig. 6) – arms made to curve downward so that they appeared horizontal from floor level. The

5. The iconophile intermission

Fig. 11. Thessaloniki, Hagia Sophia, bema ceiling mosaic set under Constantine VI and Eirene.

Thessalonikan apse mosaic also followed Hagia Eirene in its inscription, a quotation from Psalm 64; this is now interrupted by a portrait of the Virgin and Christ child, which replaced the original decoration of the apse in the eleventh century. Whether the mosaic at Thessaloniki was set before or after the 787 Council is not known, though it seems logical to associate its commission with one of the imperial tours of the area, and before Constantine and Eirene fell out in 790 (see below). But whenever the mosaics were installed, the cross and the non-figural decoration continued the pattern established at Hagia Eirene under Constantine V.

Other imperial commissions: Eirene built a female monastery on the island of Prinkipo (modern Büyük adası), the largest of the Princes' islands in the sea of Marmara. This was still visible in 1920, but is now covered by tennis courts.

A number of other monuments are known only from documentary sources. Eirene is said to have taken shelter in the Church of the Virgin of the Source during an earthquake (c. 790) and to have been healed of internal bleeding by drinking the miraculous water for which the shrine

was famous. In gratitude, according to a tenth-century account: 'she, together with her son [Constantine VI], dedicated veils woven of gold and curtains of gold thread ... as well as a crown and vessels for the bloodless sacrifice decorated with stones and pearls. She also ordered that, as a lasting memorial, their portraits should be executed in mosaic on either side of the church, handing over the offerings that have been enumerated so as both to express their faith and to proclaim for all time the miracle' This is probably an accurate inventory of her donations, for, as we shall see, silk production appears to have flourished during her reign, and the crown, which was presumably intended to hang over the altar, recalls Eirene's donation to Hagia Sophia in 780/1 when, Theophanes tells us, the empress gave to the church her deceased husband's crown, 'which she had further adorned with pearls'.

In addition, the *Patria* – a semi-legendary compilation of information about the monuments and topography of Constantinople, probably dating to the tenth century – credits Eirene with the construction of a cemetery, a bakery for the poor, and a hospice. Patriarch Tarasios, we are told by his biographer, built houses 'for the sake of our brothers, whether strangers in need of hospitality or the poor', though this is attributed to the empress in other sources. Even if only partially accurate, these commissions demonstrate that Eirene and her circle continued the consolidation and augmentation of the urban infrastructure of Constantinople that began under Constantine V.

In short, Eirene, Constantine VI and their entourage carried on the work begun by Constantine V in Constantinople, and such decoration as we know they commissioned also continued patterns familiar during his reign. In terms of courtly patronage, the 787 Council had little impact.

Non-imperial commissions: the cross-in-square church plan: There was also, however, a considerable amount of non-imperial building at the close of the eighth century, and a new type of church was developed that would soon become the dominant architectural form across the entire Orthodox world. This is the cross-in-square plan, characterised by a central dome, and internal columns which, as can be seen in Fig. 12, form a cross shape within the square area of the body of the church.

The new church plan appears to have been developed outside the capital, along the southern coast between modern Bandırma and Gemlik

5. The iconophile intermission

Fig. 12. Trilye (Zeytinbağı), church plan.

(Kios) across the Sea of Marmara, where an extraordinary number of monastic churches were built during the years on either side of 800. Six churches remain, all in the general vicinity of Mount Olympos (Bithynia), which saints' lives claim to have been a hive of monastic activity throughout the period of iconomachy. One of them, in Trilye (Zeytinbağı) has recently been dated (by dendrochronology, the analysis of the tree rings in the wood used in the church's construction) to just after 799. It has been tentatively identified as the Trigleia monastery, and is the earliest datable cross-in-square church known (Fig. 12). Two of the other six churches surviving in the area show variations of the same theme, so we can speculate with some assurance that the cross-in-square plan was being developed by Byzantine masons in the region across the last decades of the eighth century. At Trilye, fragments of mosaic still survive, along with considerable architectural sculpture. Though small,

the church's innovative construction technique and apparently lavish decoration indicate that the economic prosperity of the period was not confined to the largest monasteries or to the capital.

This can also be seen in the number of new monasteries that seem to have been founded on family lands during the last decades of the eighth century. In the 780s, for example, both the patriarch Tarasios and Theophanes the Confessor (author of the *Chronicle* so often quoted in this book) are said to have founded monasteries on lands near their family estates. These no longer survive, but sufficient new building has been preserved from the period to indicate that the economy was on an upswing.

Monastic reform and new technologies of writing

As we saw in Chapter 4, the eighth century saw the construction of many monasteries that no longer survive. One of these was founded around 783 by two members of an eminent Constantinopolitan family, a man called Plato and his nephew Theodore, who would later be canonised as Theodore of Stoudios. In 759, while still in his 20s, Plato had retired from a post in the imperial treasury to enter the monastic life on Mount Olympos, where he ultimately became abbot (*hegoumenos*) of the monastery of Symbola; he was joined there by Theodore in 781. Sometime before 787 the pair built a new monastery (Sakkoudion) on family lands, recalling the similar activity documented for Tarasios and Theophanes at the same time. The main church was dedicated to John the Baptist, and we know from the *Life* of Theodore that it was domed and decorated in mosaic. Money, in other words, was spent.

Theodore moved back to Constantinople in 798/9, and Eirene gave him the monastery of St John the Baptist of Stoudios, one of the oldest monasteries in the capital. Theodore and Plato had already begun the process of reforming Byzantine monasticism, and the move to Constantinople brought these changes – which Theodore presented as restorations of past practice – to a wider forum.

The so-called Stoudite reforms had three main planks: the institution of a *Rule of the Fathers* intended to restore the traditions of the fourth-century Church Fathers (especially St Basil of Caesarea) to monastic life; the elevation of coenobitic (communal) over eremitic (solitary) monasticism; and the importance of monastic poverty and charity.

5. The iconophile intermission

Fig. 13. Constantinople, Monastery of St John the Baptist of Stoudios.

Theodore was also an enthusiastic supporter of icons, and it is thus doubly unfortunate that, while the now-roofless and dilapidated main church of the Stoudios monastery remains (Fig. 13), no evidence of any late eighth- or early ninth-century modifications survives. Theodore's epigrams have, however, been interpreted as referring to a series of wall paintings within the monastery depicting its patron saint John the Baptist, and portraits of saintly theologians and monks.

The introduction of minuscule: Theodore encouraged reading and the copying of texts, and thus created a fertile ground for the development of an important shift in medieval writing technologies. This occurred around the year 800, when – in both Greek and Latin manuscripts – majuscule (capital or upper case letters) began to be replaced by minuscule. Greek minuscule letters are in 'lower case' (A becomes α, B becomes β, Γ becomes γ, and so forth), are often joined together forming ligatures, frequently resort to abbreviations (such as k/ for *kai* = and) and are augmented by accents and punctuation. The invention of minuscule made books considerably cheaper to produce: it was faster to write than majuscule, and smaller, so that more letters could be written

on a page. Unsurprisingly, it soon supplanted majuscule for all but deluxe manuscripts and presentation scripts (for example, inscriptions on icons). Writing technologies became quicker and more efficient around the year 800, exemplifying yet another innovation in a period that has in the past been unjustly condemned as stagnant.

Cross-cultural exchange

Icons and pilgrimage to Mount Sinai: Traffic between Constantinople and the Holy Land remained active until *c.* 800, and pilgrimage to what is now known as St Catherine's monastery at Mount Sinai – important as the site of Christ's transfiguration and Moses' vision of the burning bush, and close to the mountain where Moses received the ten commandments – was not halted by the Arab conquest of the peninsula; indeed, the Arabs revered Sinai as well. At least four written accounts of the journey date to the late seventh, eighth and early ninth centuries. The first is a papyrus, tentatively dated to 684, from Nessana (modern Nitzana), a village in the Negev conquered by the Arabs in the 630s that lay on the route between Gaza and Sinai. This was sent by the provincial governor to an administrator of Nessana, requesting him to supply a local man to guide a freed slave 'on the trip to the Holy Mount'. A slightly earlier papyrus, dated to December 683 (?), also from the governor, reads: 'When my wife Ubayya comes to you, furnish her a man bound to direct her on the road to Mount Sinai. Also furnish the man's pay.' The former was perhaps a Muslim pilgrim; the latter certainly was. More female pilgrims, but this time Christian ones, are recorded in the *Life* of Stephen the Sabaite (†794), written shortly after 807 by Leontios of Damascus, which mentions two women from Damascus who made regular pilgrimages to Jerusalem and Mount Sinai. Finally, around the year 800, a compilation ascribed to one Epiphanios Hagiopolites described travels around Palestine, Egypt and Sinai, beginning in Cyprus and ending in Jerusalem.

This Christian traffic is significant for our understanding of nine icons now held at the monastery that probably date to the years on either side of 800. They show the Crucifixion; the Nativity; John the Baptist and (probably) the Virgin Mary; the monastic saints Chariton and Theodosios; saints Paul, Peter, Nicholas and John Chrysostom; saint

5. The iconophile intermission

Fig. 14. Icon of saint Eirene with Nicholas of the Sabas monastery at her feet.

Eirene, with Nicholas of the Sabas monastery in Jerusalem prostrate at her feet (Fig. 14); saint Kosmas; and saint Merkourios. These panels demonstrate that icon production continued during iconomachy, at least in areas outside of Byzantine imperial control. They are not,

however, 'luxury icons': there is little use of gold leaf and no evidence that they ever had elaborate metal decoration, which most deluxe icons acquired. Either they were not products of a wealthy urban centre, or they were produced for clients of restricted means. Both, probably, for it seems likely that many, if not all, of the icons were painted at the monastery: for a pilgrim to carry a large panel to Sinai on his or her journey – unless it was a very important, miracle-working icon indeed – would simply not be practical. Although the varied style of the icons in question has suggested to some scholars that the icons were painted in several disparate locations, we must remember that Mount Sinai did not exist in a vacuum and the population of the monastery was mobile: monks do not normally reproduce themselves and pilgrims from all over the Mediterranean regularly appeared. The artisanal pool was therefore variable and eclectic. Residents and pilgrims alike presumably included artisans capable of painting icons, perhaps as votive gifts to the monastery, and the immigrant population base easily accounts for the stylistic diversity of the Sinai icons.

The mixture of styles makes it all the more interesting that the subject matter of the icons is restricted to three themes: the Crucifixion, the Nativity and holy portraits. The Crucifixion and the Nativity both focus on Christ's human nature, a topic of particular importance to the pro-image faction as we have seen. The icons of the saints exemplify the role of the icon as a site of divine presence and mediator between a saint and his or her clients that crystallised during our period. That the icon of saint Eirene (Fig. 14) is the oldest known example to depict the donor-client (Nicholas, in this case) with the saint portrayed is entirely fitting in this context.

Silks and cross-cultural exchange: Silk technology was imported into Byzantium from China in, apparently, the sixth century. Until the middle of the ninth century, when sericulture (the production of silk) was exported to Spain, silk was only available from the eastern Mediterranean and had to be imported to the West. It was always a luxury fabric, and the highest quality Byzantine silks were apparently woven in special imperial workshops, with certain colours made from particularly expensive dyes (notably purple and some forms of red) reserved for imperial use or imperial gift giving.

5. The iconophile intermission

Unfortunately, Byzantine textiles are hard to date, and no examples can be definitively assigned to the years between 787 and 815. As we have already seen, however, Eirene donated 'veils woven with gold and curtains of gold thread', presumably silk, to the Church of the Virgin of the Source sometime between 780 and 797. There are, in addition, frequent mentions of 'Byzantine silks' in the west during the interim period. It is not, therefore, surprising that specialist studies now group a number of silks around the year 800.

The *Book of the Popes*, which we have mentioned often, includes lists of the gifts given by various popes to assorted churches, and amongst the favoured offerings were eastern silks. Silks with religious scenes were presumably Byzantine rather than Islamic imports, and when these are specified in the *Book of the Popes* they fall into three chronological clusters – eight in 798/800, six in 812/3, and five in 813/4 – which suggests that the importation of Byzantine figural silks with religious scenes correlates with the pro-image interlude during the reign of Eirene and her immediate successors. An entry from the *Book of the Popes* is habitually cited in connection with two of the most notable surviving examples, two exceptional fragments with interlaced medallions enclosing scenes of the Annunciation and the Nativity (Figs 15-16), now in the Vatican collections. The *Book of the Popes* notes that curtains 'with disks and wheels of silk' – presumably medallions, as seen on the Vatican

Fig. 15. Annunciation silk.

Fig. 16. Nativity silk.

fragments – that showed the Annunciation and Nativity along with other scenes from Christ's life were given to Sant Apollinare in Classe (the main church of the port of Ravenna) in 813/4. This passage, though probably not a reference to the silks now in the Vatican, confirms the availability of similar silks in early ninth-century in Rome.

The subject matter of the figural silks of *c.* 800 ranges from fairly complex religious scenes (as on the Vatican medallions), to traditional

5. The iconophile intermission

Fig. 17. Sasanian hunters silk.

images of the hunt associated with the imperial house, and even to mythological narratives and personifications. Some silks that apparently date from this period depict motifs which have been characterised as 'Sasanian', such as Persian kings hunting (Fig. 17). Just as the *Book of the*

Fig. 18. Amazon silk.

Popes documents cultural exchange between Byzantium and the West, the 'Sasanian' silks are indicative of cultural – and perhaps technological – exchange between the Caliphate and Byzantium. As we shall see, a taste for Islamic motifs was attributed to the emperor Theophilos (829-842), and the 'Sasanian' silks produced *c.* 800 suggest he was not unusual in this. The issue of cross-cultural exchange between Islam and Byzantium is also raised by a group of silks showing Amazon women hunting (Fig. 18), some of which incorporate crosses while others include passages from the Qu'ran. Here, either the same design was being simultaneously produced in both Arab and Byzantine weaving centres – in which case we must assume that pattern books were exchanged between them – or silk workshops adapted patterns to suit different sets of clientele. This type of adaptation certainly occurred in other media: for example, a workshop in northern Iran embroidered fabrics with a Muslim inscription for local use, an invocation to the Trinity for export to Christian clients. But

5. The iconophile intermission

whether pattern books circulated across the Empire and Caliphate, or workshops were sufficiently adaptable to produce variant products to suit different buyers, silk production demonstrates that cross-cultural exchange continued to thrive despite hostilities between the Christian and Islamic worlds.

Constantine VI and Eirene

Constantine VI was nine years old when his father died in 780. For the next decade, he ruled jointly with his mother, the regent Eirene. The gold coins struck during this period (780-790) continued earlier practice, with the reigning Constantine VI and Eirene on the front (obverse) and their ancestors Constantine V, Leo III and Leo IV seated together on the reverse (Fig. 19). There are a number of unusual features here, including the appearance of Eirene, the first woman to be portrayed on a Byzantine coin for over 150 years. Equally notable is the continuation of the Isaurian dynastic formula, with deceased rulers – despite the iconoclast beliefs of at least two of them – on the reverse of the coins: the change of policy regarding sacred images in 787 had no impact on the practice of the imperial mints. It is also remarkable that Constantine VI is portrayed as beardless across the entire run of coinage. In the visual language of the Byzantines, to be shown unbearded meant that one was the junior emperor. This made sense in 780, when Constantine VI was nine; but

Fig. 19. *Nomisma* (gold coin): Constantine VI and Eirene (obverse), Leo III, Constantine V and Leo IV (reverse), 780-790.

by 790 he was nineteen and remained beardless on the coins: visually, he continued to be subservient to his mother. The oddities continue in the inscriptions on the coins. These follow the formula 'Constantine and Eirene his mother', but the inscription begins on the reverse and continues on the obverse, so that Constantine's name is on the back and Eirene's is on the front of the coin.

Under these circumstances, it is perhaps not surprising that Constantine VI became restless. He apparently planned to remove his mother's closest advisors, but one of them learned of the plot, and Eirene had the conspirators punished and Constantine VI confined to his quarters in the palace. Despite her precautions, Constantine was proclaimed sole emperor in November of 790. Eirene was placed under house arrest in her palace, the Eleutherios. She was not, however, formally deposed, and her name continued to appear on the coinage. Now, however, the inscription began on the front, so that Constantine's name appeared on the obverse and Eirene's was relegated to the reverse (Fig. 20). Two years later, however, Eirene was returned as co-ruler, and once again the gold coinage responded to her shifting status: Eirene was now alone on the obverse while Constantine VI, still beardless, was relegated to the reverse, where he replaced the ancestors (Fig. 21). Shortly thereafter, in 793, Constantine VI crushed a revolt against himself, but the 'moichian controversy', which began in 795, sealed his fate.

The 'moichian controversy' and the deposition of Constantine VI: In 795 Constantine VI forced his wife Maria to enter a convent (he accused her, probably unjustly, of trying to poison him) and married his mistress Theodote, who was, as it happened, a member of the same important Constantinopolitan family as Plato and Theodore of Sakkoudion (and soon Stoudios). The marriage was adulterous – *moicheia* means adultery in Greek – but neither the patriarch Tarasios nor the public offered any opposition. However, despite the advantages that would have presumably come their way through a close relationship with the imperial family, Plato and Theodore denounced the marriage and sought to excommunicate the patriarch Tarasios for his compliance in accepting it. In 797 Constantine VI ordered that the monastery of Sakkoudion be closed, imprisoned Plato and banished Theodore to Thessaloniki.

The punishment of two members of an élite family from the capital

5. The iconophile intermission

Fig. 20. *Nomisma* (gold coin): Constantine VI and Eirene (obverse), Leo III, Constantine V and Leo IV (reverse), 790-792.

Fig. 21. *Nomisma* (gold coin): Eirene (obverse) and Constantine VI (reverse), 792-797.

apparently precipitated considerable hostility, which Eirene seems to have exploited. Constantine VI was captured, blinded and deposed in August of 797; he died of the blinding. Eirene became sole ruler of the empire, Plato and Theodore were recalled and reconciled with the patriarch Tarasios, and, within the year, Theodore was made abbot of the Stoudios monastery. Unsurprisingly, he became one of the empress's strongest supporters.

The empress Eirene (797-802): The coinage changed immediately (Fig. 22). On the gold *nomismata* struck in Constantinople, Eirene appears on both sides of the coin, for the first time ever. Why the double portrait

Fig. 22. *Nomisma* (gold coin): Eirene (obverse) and Eirene (reverse), 797-802.

was favoured rather than a portrait backed with a cross – the pattern followed on Eirene's copper coins – is unclear. The rationale was, however, apparently understood by later emperors: the double portrait *nomisma* was revived by Leo V and Michael II. The economic recovery that has been postulated throughout this chapter receives support from the weight of Eirene's copper coinage, which was twice that of those struck under her son.

Eirene's rule was apparently popular. Theophanes, writing only shortly after her death, tells us that she: 'remitted the civic taxes for the inhabitants of Byzantion [Constantinople] and cancelled the so-called *komerkia* [tax] of Abydos and Hieron [custom houses controlling sea traffic between the Mediterranean and the Black Sea]. She was greatly thanked for these and many other liberalities'. Theodore of Stoudios goes even further, and claims that she cancelled virtually all transportation fees along with 'work taxes' imposed on fishermen, hunters, artisans and small-goods traders. As ever, lowering taxes was a politically expedient move.

Theophanes also tells us that Charlemagne 'intended to make a naval expedition against Sicily, but changed his mind and decided to marry Eirene instead'. Theophanes, at least, wanted his readers to take Charlemagne's proposals seriously, for he returned to them in his account of the following year (802), when, he says, 'There also arrived emissaries sent by Karolos [Charlemagne] and pope Leo to the most pious Eirene asking her to marry Karolos and so unite the eastern and western parts

5. The iconophile intermission

[of the former Roman Empire]. She would have consented had she not been checked by ... Aëtios, who ruled by her side and was usurping power on behalf of his brother.'

Aëtios was not successful in his attempt to install his brother Leo on the throne. He was forestalled by Nikephoros, *logothetes* of the *genikon* (the equivalent of the British chancellor of the exchequer, or the American secretary of the treasury), who usurped power in October 802. The patriarch Tarasios crowned Nikephoros I (802-811) in the church of Hagia Sophia. Eirene was banished first to her monastery on the island of Prinkipo (mentioned above), then to Lesbos, where she died in August 803. Soon thereafter, the former *logothetes* of the *genikon* raised taxes once more.

Nikephoros I (802-811) and Michael I Rangabe (811-813)

After cancelling most of the tax breaks granted by Eirene, Nikephoros I halted the payments made to the 'Abbasid caliph Harūn al-Rashīd. He also seems to have reorganised the army's administrative and military units and to have restructured the way that the army was paid and supplied, by shifting maintenance costs to the province the army unit was protecting. He then reformed the Empire's financial system. Theophanes – and, one presumes, many other wealthy Byzantines, hard hit by Nikephoros' new policies – hated him. 'Men who lived a pious and reasonable life wondered at God's judgement, namely how he had permitted a woman who had suffered like a martyr on behalf of the true faith to be ousted by a swineherd', Theophanes wrote, adding that 'a general gloom and inconsolable sadness gripped everyone'.

A rebellion ensued, with the aim of restoring Eirene. But Eirene had died in August 803, and the revolt sputtered out. Theophanes was not, however, alone in his dislike for Nikephoros I, and hostility to various imperial initiatives continued. The Stoudite faction, for example, objected to the emperor Nikephoros' appointment of the layman Nikephoros to the patriarchate after Tarasios' death in 806. The Stoudites wanted a monk as patriarch, preferably Theodore of Stoudios himself. This failed, and when the two Nikephoroi – emperor and patriarch – convoked a synod that declared (posthumously) that Constantine VI's marriage to Theodote had been legal, the Stoudites revived the 'moichian controversy'

and persuaded Theodore's brother Joseph, archbishop of Thessaloniki, to refuse to celebrate the Christmas liturgy with the patriarch and the emperor. This of course led to a confrontation, which the patriarch and emperor won. Theodore, Plato and Joseph were banished to the Princes' Islands; and the Stoudite mutiny had precisely the opposite effect to that it had intended. Rather than force the emperor to be subject to the rules of the church, a second synod, in 809, decreed that the emperor was not bound by canon law. This was a substantial concession, and we will return to the implications (p. 98 below).

Meanwhile, inevitably, minor Byzantine skirmishes with the Arabs continued inconclusively. Even these largely ceased in 809 with the death of Harūn al-Rashīd – which led to a major civil war within the Caliphate itself – and the situation along the Arab frontier substantially improved. In any event, Nikephoros I concentrated on the Balkan frontier and, in 805, Byzantine forces took back most of the Peloponnese. The conflict with the Bulgarians then escalated. In 811, Nikephoros I took the Bulgar capital at Pliska, but the imperial forces were then trapped by a surprise attack, and Nikephoros was killed in the battle. According to Theophanes, who was not displeased by Nikephoros' death, the Bulgar khan used his skull as a drinking cup.

Nikephoros' son Staurakios, badly wounded in 811, was acclaimed emperor, but he was too ill to resist a coup, and Michael I Rangabe was proclaimed emperor.

Michael I (811-813) is best remembered for his recognition of Charlemagne as emperor (of the West, not 'of the Romans'), twelve years after Charlemagne had in fact been given the title by pope Leo III in Rome. He also recalled the Stoudites from the exile imposed by Nikephoros I, and, less happily, was wholly unsuccessful against the Bulgars, who were unsurprisingly on the attack. The war lost much territory gained under Constantine V, Constantine VI and Eirene. After a particularly catastrophic defeat in 813, Michael abdicated and entered a monastery. Leo the Armenian, commander of the *Anatolikon thema* (military division), was acclaimed emperor by his soldiers, and crowned by patriarch Nikephoros in July 813. One of his early acts was to revive the ban on religious images. The iconophile interlude was over.

5. The iconophile intermission

References

For **Theophanes on Leo IV**, see his *Chronicle* (as in Chapter 3), 453, English tr. Mango and Scott (as in Chapter 3), 625.

On the late texts associating **Eirene with icons** during Leo IV's lifetime, see Brubaker and Haldon, *Byzantium in the Iconoclast Era: the sources* (as in Chapter 1), 71-2.

For **Constantine V's gift to pope Zacharias**, see the *Book of the Popes* (as in Chapter 3), 433, English trans. Davis (as in Chapter 3), 46. On this, and the subsequent **gift by pope Hadrian**, see further F. Marazzi, *I 'patrimonia sanctae romanae ecclesiae' nel Lazio (secoli IV-X). Struttura amministrativa e prassi gestionali*, Istituto storico italiano per il medio evo n.s. 37 (Rome, 1998), 274-88, esp. 279. For further bibliography on Byzantium and Italy, see below.

On the **planning of the council and its initial disruption**, see Theophanes, *Chronicle* (as in Chapter 3) 458-61, Eng. tr. Mango and Scott (as in Chapter 3), 632-4. On the **absences of the Constantinopolitan clergy**, see Mansi xiii, 408-13; and for **Tarasios' opening remarks**, see Mansi xii, 999.

For the *Acts* **of Nikaia II**, see Mansi xiii (in Greek); session six has been translated into English: see Sahas, *Icon and Logos* (as in Chapter 4).

For **Hadrian's letter about the planned council**, see L. Wallach, 'The Greek and Latin versions of II Nicaea and the Synodica of Hadrian I (JE 2449)', *Traditio* 22 (1966) 103-25.

For **Hadrian's response to *Against the Synod*** – known as the *Hadrianum* – see *Monumenta Germaniae Historica (Epistolarum)*, 8 vols (Berlin, 1887-1939): Epist. Karol. aevi III, 5-57 (JE 2483).

The ***Opus Caroli Regis*** has recently been edited by A. Freeman and P. Meyvaert, *Opus Caroli Regis contra Synodum* (Hannover 1998). See also A. Freeman, 'Carolingian orthodoxy and the fate of the *Libri Carolini*', *Viator* 16 (1985), 65-108; *eadem*, 'Scripture and images in the *Libri Carolini*', *Testo e immagine nell'alto medioevo*, Settimane di Studio del Centro italiano di Studi sull'Alto Medioevo 41 (Spoleto, 1994), 163-88; and Noble, *Images, Iconoclasm, and the Carolingians* (as in Chapter 4), 158-206. For Gregory I's view on images, see C. Chazelle, 'Pictures, books and the illiterate: Pope Gregory I's letters to Serenus of Marseilles', *Word and Image* 6 (1990), 138-53.

Inventing Byzantine Iconoclasm

The passage about **Eirene's gifts to the Church of the Virgin** (p. 66) was translated into English in Mango, *Art of the Byzantine Empire* (as in Chapter 4), 156-7. For the **Hagia Sophia crown**, see Theophanes, Chronicle (as in Chapter 3), 454, English tr. Mango and Scott (as in Chapter 3), 627. For her other contributions see P. Magdalino, *Constantinople médiévale: études sur l'évolution des structures urbaines*, Travaux et Mémoires du Centre de Recherche d'Histoire et Civilization de Byzance, Monographies 9 (Paris, 1996), 23-4.

For the **quotation from the *Life* of Tarasios** (p. 66), see S. Efthymiadis, *The Life of the Patriarch Tarasios by Ignatios the Deacon*, Birmingham Byzantine and Ottoman Monographs 4 (Aldershot, 1998), 94-95 (Greek), 180 (English tr.).

For the **passage about silk** cited on p. 73, see the *Book of the Popes* (as in Chapter 3) II, 32, 79; English tr. Davis (as in Chapter 3), 228.

For Theophanes on the **conspiracy, oath and Eirene's imprisonment** (p. 78), see his *Chronicle* (as in Chapter 3), 464-7, English tr. Mango and Scott (as in Chapter 3), 638-41.

On the **793 revolt** against Constantine VI, see Theophanes, *Chronicle* (as in Chapter 3), 468-9, English tr. Mango and Scott (as in Chapter 3), 643-4.

For the **passages from Theophanes** quoted on p. 80, see his *Chronicle* (as in Chapter 3), 475, English tr. Mango and Scott (as in Chapter 3), 653-4. For **Theodore**, see his 7th letter, in Fatouros (as in Chapter 4). Aëtios, a close advisor of Eirene, was a eunuch and therefore unable to seize power for himself, as eunuchs were barred from becoming emperor. On the role of eunuchs in Byzantium see K. Ringrose, *The Perfect Servant: eunuchs and the social construction of gender in Byzantium* (Chicago, 2003) and any of the many publications by Shaun Tougher, for example, *The Eunuch in Byzantine History and Society* (London, 2008).

For the **passages from Theophanes** on p. 81, see his *Chronicle* (as in Chapter 3), 476-77, Eng. tr. Mango and Scott (as in Chapter 3), 655. For the tale of the **drinking vessel made from Nikephoros' skull**, see *ibid.*, 491 (Mango and Scott, 674).

For a later **Byzantine account of the battles with the Arabs**, see Theophanes, *Chronicle* (as in Chapter 3), 455, 463, English tr. Mango and Scott (as in Chapter 3), 627, 637.

5. The iconophile intermission

Bibliography

On the introduction of **dynastic succession** under the Isaurian emperors, see G. Dagron, *Emperor and Priest: the imperial office in Byzantium*, tr. J Birrell (Cambridge, 2003); rev. edn of *idem*, *Empereur et prêtre: etude sur le 'césaropapisme' byzantin* (Paris, 1996).

On the **coinage of the Isaurian dynasty**, see P. Grierson, *Catalogue of the Byzantine Coins in the Dumbarton Oaks Collection and in the Whittemore Collection* III: *Leo III to Nicephorus III, 717-1081* I (Washington DC, 1973), 226-351.

On the situation in **Italy**, see T. Brown, *Gentlemen and Officers: imperial administration and aristocratic power in Byzantine Italy AD 554-800* (London, 1984), 144-63, esp. 158; Noble, *The Republic of St Peter* (as in Chapter 4), esp. 40-60, 132-7; and the brief overview in Herrin, *Formation of Christendom* (as in Chapter 1), 414-15.

For **Telerig**, see Theophanes, *Chronicle* (as in Chapter 3), 451, English tr. Mango and Scott (as in Chapter 3), 622.

The paragraphs on the **787 Council** were originally published in my entry on 'Icons and iconomachy' in L. James, *Blackwell Companion to Byzantium* (Oxford, 2010), 332-4. I have revised them here. On the Council, see also Herrin, *Formation of Christendom* (as in Chapter 1), 417-24, and the collection of articles in F. Boespflug and N. Lossky (eds), *Nicée II, 787-1987: douze siècles d'images religieuses* (Paris, 1987).

On the proposed **marriage between Constantine VI and Rothrud**, see Theophanes, *Chronicle* (as in Chapter 3), 455, 463, English tr. Mango and Scott, 628, 637-8. On Byzantine-Frankish relations during the reigns of Constantine VI and Eirene, see Noble, *Images, Iconoclasm and the Carolingians* (as in Chapter 4), esp. 70-84, 158-206; Herrin, *Formation of Christendom* (as in Chapter 1), 412-13, 426-8, 434-44, 445-66.

On **Hagia Sophia, Thessaloniki**, see R. Krautheimer, *Early Christian and Byzantine Architecture*, 4th edn (Harmondsworth, 1986), 290-95; Ousterhout, 'The architecture of Iconoclasm' (as in Chapter 4), 10; V. Ruggieri, *L'architettura religiosa nell'impero bizantino (fine VI-IX secolo)* (Messina, 1995), 145-50. The cubes outlining the cross were removed and replaced by gold cubes, but a faint outline of the cross remains visible, even in reproductions.

For **Eirene's monastery on Prinkipo**, see E. Mamboury, 'Le convent byzantin de femmes à Prinkipo', *Echos d'Orient* 19 (1920), 200-8; Janin, *Les églises et les monastères des grands centres byzantins* (as in Chapter 4), 69; Thomas, *Private religious foundations* (as above), 123-4; Ruggieri, *Byzantine religious architecture* (as above), 209-10. On the **churches near Mount Olympos**, see H. Buchwald, *The Church of the Archangels in Sige near Mudania*, Byzantina Vindobonensis 4 (Graz, 1969); Mango and Ševčenko, 'Some churches and monasteries' (as above). For the **Trilye dating**, see Ousterhout, 'The architecture of iconoclasm' (as in Chapter 4), 12-13, figs 5-6.

On **Tarasios' and Theophanes'** monasteries, see Efthymiadis, *The Life of the Patriarch Tarasios* (as above), 98-9, 136-42 (Greek), 181, 195-7 (English tr.); on the **monasteries along the Marmara**, see C. Mango and I. Ševčenko, 'Some churches and monasteries on the southern shore of the sea of Marmara', *Dumbarton Oaks Papers* 27 (1973), 264; J. Thomas, *Private Religious Foundations in the Byzantine Empire*, Dumbarton Oaks Studies 24 (Washington DC, 1987), 123-5; V. Ruggieri, *Byzantine Religious Architecture (582-867): its history and structural elements*, Orientalia Christiana Analecta 237 (Rome, 1991), 202-03. For **Byzantine architectural practice**, see R. Ousterhout, *Master Builders of Byzantium* (Princeton NJ, 1999).

For the **Sakkoudion monastery**, see Janin, *Les églises et les monastères des grands centres byzantins* (as in Chapter 4), 177-81; Ruggieri, *Byzantine Religious Architecture* (as above), 225-6. For the **Stoudios monastery**, see C. Mango, 'The date of the Studios basilica at Istanbul', *Byzantine and Modern Greek Studies* 4 (1978), 115-22; R. Janin, *La géographie ecclésiastique de l'empire byzantine, I: le siège de Constantinople et le patriarchate oecuménique III. Les églises et les monastères* (Paris, 1969), 430-40; Ruggieri, *Byzantine Religious Architecture* (as above), 195-6.

On the **monastic reforms initiated by Theodore of Stoudios**, see R. Morris, *Monks and Laymen in Byzantium 843-1118* (Cambridge, 1995), 13-19. For the *Rules*, see J. Thomas and A. Hero (eds), *Byzantine Monastic Foundation Documents I* (Washington DC, 2000), 97-115.

For the **new technologies of writing**, see C. Mango, 'L'origine de la minuscule', *La paléographie grecque et byzantine*, Colloques Internationaux du Centre National de la Recherche Scientifique, 559 (Paris, 1977), 175-80 ; B. Fonkič, 'Aux origins de la minuscule Stoudite

5. The iconophile intermission

(les fragments muscovite et parisien de l'oeuvre de Paul d'Égine)', in G. Prato (ed.), *I manoscritti greci tra riflessione e dibattito* I, Atti del V Colloquio Internazionale di Paleografia Greca (Florence, 2000), 169-86.

For **travel in the Holy Land** at this time, see S. Griffith, 'What has Constantinople to do with Jerusalem? Palestine in the ninth century: Byzantine orthodoxy in the world of Islam', in L Brubaker (ed.), *Byzantium in the Ninth Century: dead or alive?* (Aldershot, 1998), 181-94; C. Mango, 'Greek culture in Palestine after the Arab conquest', in G. Cavallo, G. de Gregorio and M. Maniaci (eds), *Scritture, libri e testi nelle aree provinciali di bisanzio* I (Spoleto, 1991), 149-60; and on the routes see Brubaker and Haldon, *Byzantium in the Iconoclast Era: the sources* (as in Chapter 1), 57. Full references to the accounts cited in the text may be found in *ibid.*, 57-8. The **icons** noted here are inventoried as Sinai B.32, B.33, B.34-B.35 (two panels that were probably once joined as a diptych), B.37, B.39, B.41, B.47, B.49. They were published by K. Weitzmann, *The Monastery of Saint Catherine at Mount Sinai. The Icons I: from the sixth to the tenth century* (Princeton NJ, 1976), 57-8, 58-9, 60-1, 64-9, 77-9, fig. 30, pls XXIII, XXIV, XXVI, XXVII, XXXI, LXXXIV-LXXXVIII, XCI, XCIII, XCV, CII, CIV. For detailed discussion and a consideration of the problems surrounding the dating of the icons, see Brubaker and Haldon, *Byzantium in the Iconoclast Era: the sources* (as in Chapter 1), 55-74. K. Weitzmann, 'Loca sancta and the representational arts of Palestine', *Dumbarton Oaks Papers* 28 (1974), 50-1; repr. in *idem, Studies in the Arts at Sinai* (Princeton, 1982), agrees that icon production continued during 'iconoclasm'.

The bibliography on **Byzantine silks** is voluminous. For a general introduction see A. Muthesius, *Byzantine Silk Weaving AD 400 to 1200* (Vienna, 1997). On the **Annunciation, Nativity and 'Sasanian' silks**, see esp. A. Starensier, 'An art historical study of the Byzantine silk industry', PhD thesis (Columbia, 1982), 545, 554-6, 571-6. The literature most relevant to the discussion here has been collected in Brubaker and Haldon, *Byzantium in the Iconoclast Era: the sources* (as in Chapter 1), 80-108; to which should be added D. King, 'Patterned silks in the Carolingian empire', *Bulletin de Liaison du Centre International d'Étude des Textiles Anciens* 23 (1966), 47-9; M. and D. King, 'The annunciation and nativity silks: a supplementary note', *Bulletin de Liaison du Centre International d'Étude des Textiles Anciens* 63-4 (1986), 20-1; R. Schorta

in C. Stiegemann and M. Wemhoff (eds), *799: Kunst und Kultur des Karolingerzeit. Karl der Grosse und Papst Leo III. in Paderborn* (Mainz, 1999), no. IX.38. On **pattern books** for silks see A. Stauffer, 'Cartoons for weavers from Graeco-Roman Egypt', in D.M. Bailey (ed.), *Archaeological Research in Roman Egypt* (Ann Arbor MI, 1996), 223-30; eadem, 'Une soierie "aux Amazones" au Musée Gustav Lübcke a Hamm: *à propos de la diffusion des cartons pour la production des soies figurées aux VIIe/ Xe siècles*', *Bulletin de Liaison du Centre International d'Étude des Textiles Anciens* 70 (1992), 45-52. For the **Persian textiles**, see R. Lopez, 'Silk industry in the Byzantine Empire', *Speculum* 20 (1945), 23, who notes the same phenomenon on papyrus from the ninth century.

For the **coins** of Constantine VI and Eirene, see Grierson, *Catalogue of the Byzantine Coins in the Dumbarton Oaks Collection* (as above), 337-9.

On the **'moichian controversy'** and **Constantine VI's deposition**, see Theophanes, *Chronicle* (as in Chapter 3), 469-72, English tr. Mango and Scott (as in Chapter 3), 645-9; and discussion in Herrin, *Formation of Christendom* (as in Chapter 1), 431.

For accounts of **Nikephoros I's reign**, see P.E. Niavis, *The Reign of the Byzantine Emperor Nicephorus I (AD 802-811)* (Athens, 1987); W. Treadgold, *The Byzantine Revival, 780-842* (Stanford CA, 1988), 126-95.

On **Byzantine-Arab relations** during this period, see R.-J. Lilie, *Byzanz unter Eirene und Konstantin VI. (780-802)*, Berliner Byzantinische Studien 2 (Frankfurt, 1996), 155-69; H. Kennedy, *The Early Abbasid Caliphate: a political history* (London, 1981); and J. Haldon and H. Kennedy, 'The Arab-Byzantine frontier in the eighth and ninth centuries: military organisation and society in the borderlands', *Zbornik radova Vizantološkog instituta* 19 (1980), 79-116.

For the **Balkan strategy**, see Theophanes, *Chronicle* (as in Chapter 3), 456-7, 463, 475, English tr. Mango and Scott (as in Chapter 3), 628-31, 638, 654. For further detail, see Lilie, *Byzanz unter Eirene und Konstantin* (as above), 147-55, 172-9.

On **Byzantine-Bulgar relations** under Nikephoros I, see Curta, *Southeastern Europe in the Middle Ages* (as in Chapter 3), 111-15, 147-50.

For the **Stoudite-Nikephoros conflict**, see P. Alexander, *The Patriarch Nicephorus of Constantinople: ecclesiastical policy and image worship in the Byzantine Empire* (Oxford, 1958), 54-64, 87-96.

5. The iconophile intermission

Our main source for **Michael I's reign** is his contemporary, Theophanes, *Chronicle* (as in Chapter 3), 493-503, English tr. Mango and Scott (as in Chapter 3), 675, 677-88.

On **Leo V**, see D. Turner, 'The origins and accession of Leo V (813-820)', *Jahrbuch der österreichischen Byzantinistik* 40 (1990), 171-203.

6

The iconoclasts return

Why was 'iconoclasm' revived?

The period often known as 'second iconoclasm' lasted from 815 until 842, and was dominated by three emperors: Leo V (813-820), Michael II (820-829), and Michael's son Theophilos (829-842). Leo V did not revive the ban on holy portraits immediately, but only in 815, after serious defeats by the Bulgars in Makedonia and Thrace. He may have believed that the military defeats were a manifestation of God's anger with the Byzantines for returning to the veneration of icons. But Leo was also, according to later authors, associating himself with the last emperor known for his great military successes, the arch-iconoclast Constantine V. Traces of Constantine's reputation as a great military leader survived even the concerted later attack on his reputation, and it is clear that he was a favourite of soldiers – in one tale he is presented as a dragon-slayer and in his account of the Bulgar defeats under Leo V even Theophanes, no lover of Constantine V, included a story of soldiers breaking into the church where the emperor lay in his tomb and begging him to 'Arise and help the state that is perishing!'. Leo V's emulation of Constantine V (and his father Leo III) is particularly evident in the renaming of his son Smbat as Constantine, and his decision to move from the double portrait coinage found at the beginning of his reign (which continued the pattern established by Eirene) to Leo III's practice of stamping his son's image on the reverse of the *nomismata* (Fig. 23).

Two years after Leo V came to the throne, the pro-image patriarch Nikephoros (806-815) was forced out, and replaced by Theodotos Melissenos, who agreed to support the iconoclast position of the emperor. For the first time ever, there was monastic opposition to an imperial iconoclast position, led by Theodore of Stoudios, whose letters

6. The iconoclasts return

Fig. 23. *Nomisma* (gold coin): Leo V (obverse) and Constantine (reverse).

to the pope (and many others) argued so strongly against Theodotos' appointment as patriarch that the pope rejected it. There seems to have been no other resistance to the change, however, and despite papal resistance Theodotos was elevated to the patriarchate without incident at Easter 815. The former patriarch Nikephoros survived, and wrote the *Antirrhetikos*, a text very hostile to the iconoclast position (though especially to Constantine V, rather than to Leo V and Michael II), before his death in 828.

A council met later in the year to re-impose the ban on images. The *Acts* of this council do not survive, but the arguments it put forward can be reconstructed from later refutations. From these, we sense a less dogmatic approach to the image question than in the 750s: icons were no longer condemned as 'idols' but were simply 'incorrect' or 'false' images. In this, they opposed the 'true' image, the definition of which had broadened considerably from the 754 precept that the eucharist was the only acceptable representation of Christ. The churchmen of 815 instead identified a 'true' image as a good Christian – a human being made in God's image – in whose heart Christ dwelt. Pictorial images, manufactured by artisans rather than fashioned by God, were not admissible, and they were certainly not endowed with the 'real presence' of the saint depicted.

Leo V was murdered in 820 by his successor Michael II, who continued on Leo's iconoclast path. Both Leo and Michael stressed that they were purifying the church of unwholesome practices that had crept in over

the past few decades, and neither pretended to the theological fervour and convictions of Constantine V. Their more conciliatory beliefs are exemplified in Michael II's letter to the western emperor Louis the Pious in 824, where Michael explained that, in order to prevent the simpler and less educated members of the Christian congregation from lighting candles and burning incense around images, and the clergy from celebrating the eucharist with them, the 'pious emperors and learned priests' had decreed that those images placed low down should be removed, while those higher on the walls, removed from the possibility of any misdirected veneration, were allowed to remain. Church unity remained the overarching concern for Leo V and Michael II, just as it had been for Eirene and her patriarch Tarasios. Harmony was evidently more important than ideology. Although, as in 787, that harmony was at the expense of the losing party, iconophiles were not as marginalised as were iconoclasts after Nikaia II. Not only Nikephoros, but also Theodore of Stoudios († 826), continued to write. The veneration of icons was not 'officially' tolerated, but as long as people recognised the legitimacy of the (iconoclast) emperor and patriarch they seem to have been free to retain or obtain icons – or sacred portraits in other media such as amulets – for private use.

Until the end of 823, however, Michael II was primarily focused on a civil war, instigated by Thomas the Slav (who apparently pretended to be Constantine VI, and seems to have been recognised as emperor by the 'Abbasid caliph al-Ma'mūn, 811-833). This left him little reserve to defend Crete, which fell to the Arabs between 824 and 827. It also meant that Michael expended little energy on ecclesiastical politics.

The last iconoclast emperor, Theophilos (829-842), was a more active, though inconsistent, persecutor of those who publically promoted the veneration of icons. The loss of Palermo and most of western Sicily to the Arabs, the emperor's defeat at Muslim hands in Cappadocia in 831, and various plots against him (apparently spearheaded by the pro-image faction) – or some combination of these aggravations – prompted Theophilos to confront his most active opponents, and those who opposed the official position on icons or challenged imperial authority began to be targeted in 833. The most notable victims were two brothers, Theodore and Theophanes, who became known as the *graptoi* ('marked with writing') because Theophilos is said to have had insulting verses

6. The iconoclasts return

tattooed on their faces as punishment for their insubordination. But even those who publicly supported the veneration of icons were not always penalised: it is clear from the case of Methodios – first punished for his promotion of images, then in a sudden about-face recalled to Constantinople to advise the emperor in the palace – that some pro-image sentiment was tolerated, even at court.

But many – probably most – churchmen and monks once again complied with the official iconoclast line. It was certainly the expedient thing to do, and there are many instances of churchmen who vacillated between anti- or pro-image directives without any apparent detriment to their advancement. After the end of the image debates, for example, Ignatios (the castrated son of the former emperor Michael I) officially promoted icon veneration as patriarch of Constantinople (847-858, 867-877); but in the 830s he had been abbot of a monastery which officially accepted the imperial iconoclast policy. His older namesake Ignatios the Deacon († *c.* 848) is another example: an associate of the iconophiles Tarasios and the patriarch Nikephoros, he became archbishop of Nikaia under 'second iconoclasm', and his collected letters clearly show him toeing an iconoclast line; at the restoration of Orthodoxy in 843 he was purged, but was back in Methodios' entourage, writing biographies of Tarasios and Nikephoros, before his death.

Theophilos and the Arabs

Byzantine contacts with the Arabs have excited much interest, and it is from Theophilos' reign onward that we can trace the growing importance of cultural connections (and cultural rivalry) between the Byzantine and 'Abbasid courts. John the Grammarian – Theophilos' former tutor and, from 838, patriarch – travelled to Baghdad in 829, perhaps to try to convince an important defector to the Arabs to return to the Byzantine side; another embassy arrived in 831 to negotiate the release of prisoners. There is no evidence that, as has been proposed, John was active in al-Ma'mūn's scientific movement. All the same, according to a tenth-century source, John was so impressed by the 'Abbasid court that he persuaded Theophilos to build the Bryas palace 'in imitation' of those he had seen in Baghdad, 'in no way differing from the latter either in form or decoration' except through the addition of a chapel dedicated to

the Virgin near the imperial bedchamber and a church dedicated to the archangel Michael in the courtyard.

The Bryas complex no longer survives, so we cannot test the text against any actual monument. The account has nonetheless provoked considerable discussion, and has been interpreted either as evidence of cultural receptivity under Theophilos, or, conversely, as a later invention that was intended to portray the last iconoclast emperor and John the Grammarian (much despised by later Byzantine authors) as Islamic sympathisers. There was, in fact, considerable exchange between Constantinople and Baghdad during the reign of Theophilos, and the emperor is not unduly criticised for this in later sources, though to accuse the iconoclasts of being 'Saracen-minded' (that is, influenced by the Arab Muslims) is a reasonably familiar insult in iconophile texts. But, as we shall see, Theophilos was a great builder, and later reports of his architectural patronage are broadly positive, whatever the sympathies of the authors. It thus seems most fitting to read the account of the Bryas palace as an indication of the rising courtly interaction between the Byzantine and Islamic courts that corresponded with the increasing stability of the empire's borders and the enhanced economic situation in Byzantium, to which we shall now turn.

Theophilos as emperor

Byzantium's improved financial strength allowed Theophilos to achieve two major goals. Most importantly for the stability of the empire, he was able to bolster Byzantium's frontiers by establishing new military districts, buttressed with fresh fortifications. He also improved the defensive position of Constantinople through repairs to the land walls, the reconstruction of the sea wall, and the renewal of the wall along the Golden Horn – indeed, his renovations were so extensive that his name is mentioned in the inscriptions inserted into the walls of the capital more often than that of any other ruler. Second, Theophilos was able to continue the renewal of the infrastructural fabric of the capital, begun by Leo III and, especially, Constantine V, and to commission luxury building and decoration in the palace and at the Great Church, Hagia Sophia.

6. *The iconoclasts return*

Fig. 24. Constantinople, Hagia Sophia, southwest vestibule, 'beautiful door'.

Hagia Sophia and the new balance of power between church and state: The only surviving example of the deluxe decoration installed at Theophilos' request is the 'beautiful door' at Hagia Sophia (Fig. 24). The door, in the vestibule situated at the southwest end of the inner narthex (where most people now exit the building), was installed in 838/9 and the text inscribed on it was revised in 840/1 to accommodate the birth of Michael III. The door panels are made of wood, to which

copper-alloy plates were attached; the central panels contain eight paired monograms, inlaid with silver. Presumably in deference to the medium, the inscriptions mimic those on contemporary seals; the uppermost two read (in translation) 'Lord help the ruler Theophilos' and 'Mother of God help the empress Theodora'. The lower two originally read 'Christ help the patriarch John [the Grammarian]' and gave the date as 'the year from the creation of the world 6347, indiction 2 [838/9]'. After the birth of Theophilos' son – the future Michael III – the silver letters spelling out 'the patriarch John' and part of the date were picked out, and 'the ruler Michael' and a new date, 840/1, was inserted. At the same time an inscription was added at the top of the doors, reading 'Theophilos and Michael, victorious'.

The southwest vestibule was added to Hagia Sophia at some point after the main reconstruction of the building by Justinian in the 530s, but exactly when it was constructed is not clear. The importance of the portal in imperial ritual, and its designation as the 'beautiful door', is first attested in the written documentation only in the mid-tenth century, in the *Book of Ceremonies*, but the creation – or replacement? – of the door itself by Theophilos indicates the importance of the entrance already by 840. The adjacent baptistery was at least partially reconstructed sometime after 814, and it is possible that the remodelling and enhancement of the vestibule was part of this same campaign.

But whenever it was reconfigured, Theophilos' commission suggests that by the 840s the southwest vestibule had become the point of entry into Hagia Sophia for the emperor. Here, according to the *Book of Ceremonies*, he removed his crown, met the patriarch, and proceeded with him down the narthex and into church through the 'imperial door' (Fig. 25). This ritual made the vestibule a site of significant transition: the earthly ruler removed the sign of his office out of respect for the heavenly ruler whose territory he was now entering. In this the emperor was assisted by the 'custodian' of God's house, the patriarch, and the process thus visualised the transfer of power from one realm to another, as embodied by the heads of state and church respectively.

After the service, much of which the emperor spent in an area reserved for his use in the southeast corner of Hagia Sophia where he could view the altar, he left the church through an adjoining vestibule, the portico of the Holy Well, so-called after its most important relic, the well on

6. The iconoclasts return

Fig. 25. Constantinople, Hagia Sophia, plan showing imperial route through church.

which Christ was believed to have sat when he talked to the Samaritan woman. After giving gold to the patriarch, the emperor retrieved his crown, and, his patrimony restored, returned to the palace. The earliest mentions of the Holy Well are, like the 'beautiful door', connected with Theophilos: it is noted in passing in the letter of the three patriarchs to Theophilos (836?) and associated in the *Book of Ceremonies* with Theophilos' triumphal procession after the defeat of Islamic forces in Cilicia (830s). The textual and visual links between Theophilos and the new imperial entrance and exit portals at Hagia Sophia suggest –

though there is no way of demonstrating this conclusively – that he was responsible not only for the door marking the entry but also the reconfiguration of the imperial transit space within the Great Church.

As we saw in Chapter 3 (p. 26 above), Leo III's *Ekloge* introduced new legislation specifically inspired by Christian belief. Subsequently (p. 82 above), in 809 the emperor was, at least in theory, exempted from the restrictions of canon law. These details are part of a larger picture: the negotiation of a new balance of power between church and state. This continued to be an issue during Theophilos' reign, as we see in a passage from the *Life* of Niketas of Medikion, written before 844/5 and probably before 842. The author, the monk Theosteriktos, portrays the image struggle as an imperial heresy, and exhorts his readers to 'Know the difference between emperors and priests'. The rituals of entering and leaving Hagia Sophia, staged in what appear to be purpose-built vestibules, show that the distinction between emperor and priest was formalised and visualised here. Whether or not these rituals were initiated by Theophilos and the then patriarch, John the Grammarian, is uncertain, but the establishment of spaces dedicated to their enactment suggests that this is likely. From now onwards the patriarch had firm control of the emperor's access to the Great Church. All the same, Theophilos also put his own name very prominently on the major entry into the sacred realm.

Theophilos as builder – the Great Palace: Theophilos' palace constructions were enumerated by an anonymous author in the mid-tenth century, now known as the 'Continuator' of Theophanes, since the text continues from where the early ninth-century *Chronicle* of Theophanes the Confessor left off in 813. According to the Continuator, Theophilos built more extensively than any other emperor across the entire period of the image struggle. This is significant for several reasons. First of all, it indicates that Theophilos had sufficient surplus resources to build non-essential domestic structures. Second, the extent of the building work suggests that the emperor was consciously setting out to establish his reputation as a lavish patron. While philanthropic spending for the public good – such as, for example, the refuge for former prostitutes that the Continuator tells us that Theophilos built – was an established imperial virtue, palace building work normally had

the somewhat different goal of impressing visitors and commemorating the emperor who commissioned the work. The diplomatic exchanges with the Arabs noted earlier suggest that embassies from Baghdad were one of the audiences which Theophilos wished to impress. The Continuator stressed (as Byzantine accounts of buildings were prone to do) the exotic and precious materials used in construction: buildings sheathed in various kinds of marble, with bronze and silver doors, and a bronze fountain with a 'rim crowned with silver and a gilded cone' that spouted wine during the opening reception for the building, alongside 'two bronze lions with gaping mouths [that] spouted water'. An armoury was decorated with pictures of 'shields and all kinds of weapons'; another room had its lower walls covered with slabs of marble 'while the upper part [had] gold mosaic representing figures picking fruit'; a third had 'on its walls ... mosaics whose background is entirely gold, while the rest consists of trees and green ornamental forms'.

We are told that Theophilos built two structures known as the *Trikonchos* and the *Sigma*, placed so as to connect the older, fourth-century palace of Constantine the Great and the sixth-century *Chrysotriklinos* ('Golden Hall'). The *Sigma* opened onto a court with a fountain, spacious enough for major imperial receptions. A range of other, equally lavishly decorated, smaller buildings were associated with this complex. Elsewhere within the palatine precinct, the Continuator tells us that Theophilos constructed apartments of several storeys decorated with mosaics, marble, and many-coloured tile flooring. The whole complex was interspersed with terraces and gardens, which, like the water features mentioned earlier, were important features of all Mediterranean deluxe residences.

While we cannot know how accurate the Continuator's report of Theophilos' building programme was, the account suggests that considerable funds were expended on ceremonial public spaces, and that these were expensively decorated. This, in turn, indicates not just that Theophilos had resources to spare, but that he could command a skilled workforce to produce high-impact architecture with elaborate decoration. As we have seen in earlier chapters, innovative and high-status 'arts' did not languish during the iconoclast centuries.

Theophilos or members of his family also sponsored monastic building. Several female members of the family favoured the Monastery

of Gastria: his mother Euphrosyne retired there, and his widow Theodora was exiled (in 856) and buried there. Theodora is also said to have built a monastery dedicated to St Panteleimon, while Theophilos' son-in-law Alexios Mousele is credited with a monastery on the Asiatic shore of the Bosphoros, to which he retired after 843.

Technology and diplomacy

Mechanical devices powered by water or bellows, such as organs and furnishings that moved, seem to have been Greek specialties in the eighth and ninth centuries, and western and 'Abbasid sources suggest that Byzantine organs were especially valued in diplomatic gift exchange. One, sent to Pippin in 757, was heralded as 'not previously seen in Francia'; another Greek organ (*urghan rumi*) belonged to the caliph al-Ma'mūn. They were also made for local use in Constantinople: according to Leo the Grammarian, Theophilos commissioned 'two enormous organs of pure gold ... decorated with different stones and glasses'.

Theophilos is also associated with automata. Best known are the 'golden tree in which were perched birds that warbled musically by means of some device' and the throne that rose in the air, accompanied by the roaring of golden lions, both described a century later by Liutprand of Cremona, which are probably his commissions. Leo the Grammarian, the source of most of our information on Theophilos' metalwork, also tells us that the emperor ordered from the master of the mint a piece of furniture known as the *Pentapyrgion*, a large cupboard surmounted with five towers that sat in the throne room (*Chrysotriklinos*) of the Great Palace and apparently functioned as a display case.

Monks, nuns and monasteries

As we saw in Chapter 5, around the year 800 monastic reforms, the energetic leadership of Theodore of Stoudios, and tax-breaks for monasteries in Constantinople propelled urban monasticism into more prominence than it had enjoyed in the past. This continued during 'second iconoclasm', as is evident from monastic resistance – and however limited this was, it was nonetheless a first – to the reinstallation of the ban on icon veneration noted earlier in this chapter. In response to the

6. The iconoclasts return

increasing importance of monks, nuns, and monasteries, there are a remarkable number of monks and, to a lesser extent, nuns who became saints during the first half of the ninth century. These are known from the biographies written by their followers, which detail the lives, deaths and miracles of the holy men and women they champion.

Equally important, many of the holy monks chronicled in the hagiographies (saints' lives) set during the first third of the ninth century mention new monastic complexes founded by their heroes, often pro-image monks said to be in exile from the capital. We are told, for example, that after the restoration of the ban on icon veneration in 815 St Ioannikios (752/4-846) moved to Mount Alsos (Lissos) in Lydia, southwest of Mount Olympos, and founded churches dedicated to the Theotokos, Peter and Paul, and the martyr Eustathios. Slightly later, during the reign of Theophilos, the island of Aphousia (now Avsa adası) in the Sea of Marmara apparently became a common site of banishment and, according to their *Lives*, churches were built here by Sts Makarios of Pelekete (after 829) and Symeon of Lesbos.

In addition to the monastic complex associated with St Ioannikios near Mount Olympus, two other monks – Niketas the *patrikios* (patrician), an iconophile, and Ignatios, a sometime iconoclast (see p. 93 above) – founded extensive monastic communities. Niketas' monastery at Zouloupas (near Nikodemia) was built between 833 and 836 on land given to him by a relative – another example of family lands appropriated for monastic use (see Chapter 5) – and, after leaving Zouloupas, Niketas restored the church of St Michael at Katesia between 833 and 836. His final monastery, near Kerpe on the Black Sea, was built before 836 and Niketas was buried here. Ignatios, meanwhile, built three monasteries on islands in the Sea of Marmara: at Terebinthos, Yatros, and Plate.

Women, too, founded monasteries. Theodore of Stoudios wrote two epigrams that note a convent dedicated to the Theotokos built by Anna, wife of Leo the *patrikios*. And the poet Kassia – one of the rare female authors known from the Byzantine period – is said to have founded a monastery, apparently in the outskirts of Constantinople, where she lived and wrote until her death.

Land use and patronage-patterns during 'second iconoclasm' continue the pattern we saw emerging in Chapter 5. Some land seems to have been developed for the first time, and this suggests economic expansion.

The islands in the Sea of Marmara apparently underwent extensive development, perhaps because during the years of iconomachy they served as places of exile, and were sufficiently removed from the capital to allow considerable freedom of movement (and patronage) for banished aristocrats.

One of the more interesting general conclusions to be drawn from the evidence preserved from the iconoclast centuries is that while iconoclast emperors are credited with civic patronage such as repair of walls and aqueducts, ecclesiastical patronage in the period is less often attributed to them. The identity of many patrons is not known, and the majority of named benefactors were religious. Others, however, were civic officials or members of the urban elite, such as Anna, wife of Leo the *patrikios*, who founded the convent of the Theotokos mentioned earlier, and Niketas the *patrikios*, who as we saw sponsored several.

*

What can we conclude about 'second iconoclasm'? The ban on images was not, as far as we can see, revisited for ideological reasons, but in emulation of the strong rulership, long reigns and military success of the early Isaurian emperors, especially Constantine V. Leo V's decision to return to earlier policies was grounded in his desire to associate himself with successful earlier emperors rather than with any strong feelings about ecclesiastical policy. Only Theophilos had such strong feelings, and his patronage of Methodios shows that even these were intermittent. The grand narrative of 'iconoclasm' had played itself out. Why – and what impact it actually had – are the subjects of the final two chapters.

References

For **Theophanes on the soldiers at Constantine V's tomb** (p. 90), see his *Chronicle* (as in Chapter 3), 501, English tr. Mango and Scott (as in Chapter 3), 684; and on **Constantine V as a hero**, see S. Gero, 'The legend of Constantine V as dragon-slayer', *Greek, Roman and Byzantine Studies* 19 (1978), 155-9; M.-F. Auzépy, 'Constantin, Théodore et le dragon', in *Toleration and Repression in the Middle Ages: in memory of Lenos Mavrommatis*, National Hellenic Research Foundation, Institute

6. The iconoclasts return

for Byzantine Research, International Symposium 10 (Athens, 2002), 87-96.

On **Nikephoros'** *Antirrhetikos* (p. 91), see **References** in Chapter 4.

For the **letter to Louis the Pious** (p. 92), see Mansi xiv, 419-20 (Greek); English trans. in Mango, *Art of the Byzantine Empire* (as in Chapter 4), 157-8.

For the passage on the **Bryas palace** (p. 93), see *Theophanes Continuatus, Chronographia*, Corpus Scriptorum Historiae Byzantinae, ed. I. Bekker (Bonn, 1838), 98-9; English tr. in Mango, *Art of the Byzantine Empire* (as in Chapter 4), 160. For **interpretation**, see R. Cormack, 'The arts during the age of Iconoclasm', in A. Bryer and J. Herrin (eds), *Iconoclasm: papers given at the 9th Spring Symposium of Byzantine Studies* (Birmingham, 1977), 35-44; repr. in *idem, The Byzantine Eye: studies in art and patronage* (London, 1989), essay 3; and C. Barber, 'Reading the garden in Byzantium: nature and sexuality', *Byzantine and Modern Greek Studies* 16 (1992), 1-19, esp. 2-5; on the supposed **remains of the palace**, see A. Ricci, 'The road from Baghdad to Byzantium and the case of the Bryas Palace in Istanbul', in L. Brubaker (ed.), *Byzantium in the Ninth Century: dead or alive?* (Aldershot, 1998), 131-49.

For the **passage from the** *Life* **of Niketas** quoted on p. 98, see Dagron, *Emperor and Priest* (as in Chapter 5), 188.

For the **quotation from Leo the Grammarian** on p. 100, see Mango, *Art of the Byzantine Empire* (as in Chapter 4), 160-1.

For the **quotation from Liutprand of Cremona** on p. 100, see P. Squatriti, tr., *The Complete Works of Liudprand of Cremona* (Washington DC, 2007), 198.

Bibliography

For **'second iconoclasm'**, see M. Kaplan (ed.), *Monastères, images, pouvoirs et société à Byzance* (Paris, 2006), the second half of which is devoted to this theme; Herrin, *Formation of Christendom* (as in Chapter 1), 466-73.

For **Leo V's coins**, see P. Grierson, *Catalogue of the Byzantine Coins in the Dumbarton Oaks Collection* (as in Chapter 5), 371-2.

On the events surrounding **Nikephoros' resignation**, see Alexander, *Patriarch Nicephorus* (as in Chapter 5), 133-6.

On **Theodore and the pope**, see C. van de Vorst, 'Les relations de S.

Théodore Studite avec Rome', *Analecta Bollandiana* 32 (1913) 439-47.

On the **815 Council**, see P.J. Alexander, 'The Iconoclastic Council of St Sophia (815) and its definition (*Horos*)', *Dumbarton Oaks Papers* 7 (1953) 35-66.

Our information on the ***graptoi* brothers** comes from the *Life* of Michael the Synkellos; for the passages about the verses inscribed on their faces, see chs 20-3 in M.B. Cunningham, *The Life of Michael the Synkellos: text, translation and commentary*, Belfast Byzantine Texts and Translations I (Belfast, 1991), 84-97.

On **Methodios** and **Ignatios**, see P. Karlin-Hayter, 'Gregory of Syracuse, Ignatius and Photius', in Bryer and Herrin (eds), *Iconoclasm* (as above), 141-5; P. Karlin-Hayter, 'Icon veneration: significance of the restoration of orthodoxy?', in C. Sode and S. Takács (eds), *Novum Millennium: studies on Byzantine history and culture dedicated to Paul Speck* (Aldershot, 2001), 171-83.

On **Theophilos and the Arabs**, see J. Signes Codoñer (forthcoming); on **Byzantine-Arab exchange**, see P. Magdalino, 'The road to Baghdad in the thought-world of ninth-century Byzantium', in Brubaker (ed.), *Byzantium in the Ninth Century* (as above), 195-213; and more generally D. Gutas, *Greek Thought, Arabic Culture* (London, 1998) and Magdalino, *L'orthodoxie des astrologues* (as in Chapter 4). On **iconophile insults** see for example Theophanes, who accuses Leo III of being 'Saracen-minded' his *Chronicle* (as in Chapter 3), 405, English tr. Mango and Scott (as in Chapter 3), 560.

On **Theophilos' frontier defences**, see N. Oikonomides, *Les listes de préséance byzantins des IXe-Xe siècles* (Paris, 1972), 348-50, 353; W. Treadgold, 'Notes of the numbers and organisation of the ninth-century Byzantine army', *Greek, Roman and Byzantine Studies* 21 (1980), 269-88, esp. 286-7. On the **walls of Constantinople**, see C. Mango, 'The Byzantine inscriptions of Constantinople: a bibliographical survey', *American Journal of Archaeology* 55 (1951), 52-66, esp. 54-7; C. Foss and D. Winfield, *Byzantine Fortifications* (Pretoria, 1986), 70-1.

On the **southwest vestibule doors** at Hagia Sophia, see C. Mango, 'When was Michael III born?', *Dumbarton Oaks Papers* 21 (1967), 253-8; repr. in *idem, Byzantium and its Image* (London, 1984), study XIV; R. Mainstone, *Hagia Sophia: architecture, structure and liturgy of Justinian's Great Church* (New York, 1988), 29, fig. 28; Brubaker and

6. The iconoclasts return

Haldon, *Byzantium in the Iconoclast Era: the sources* (as in Chapter 1), 109-11. On the vestibule itself, see Cormack and Hawkins, 'The mosaics of St Sophia at Istanbul: the rooms above the southwest vestibule and ramp' (as in Chapter 4), 199-202. On the **emperor's passage through Hagia Sophia**, see Dagron, *Emperor and Priest* (as in Chapter 5), 92, 94, 99, 279-80; and C. Mango, *The Brazen House: a study of the vestibule of the imperial palace of Constantinople* (Copenhagen, 1959), 60-72. For the reference to the **Holy Well**, see J. Munitiz, J. Chrysostomides, E. Harvalia-Crook, and C. Dendrinos, *The Letter of the Three Patriarchs to Emperor Theophilos and Related Texts* (Camberley, 1997), 46-7, 72-3. Parts of the discussion here were originally published in L. Brubaker, 'Gifts and prayers: the visualization of gift giving in Byzantium and the mosaics at Hagia Sophia', in W. Davies and P. Fouracre, *Languages of Gift* (Cambridge, 2010), 33-61, which provides a fuller consideration of the vestibule and its decoration.

For Theophilos' **refuge for former prostitutes**, see *Theophanes Continuatus, Chronographia* (as above), 95; for his palace building, see *ibid.*, 139ff.; translated into English in Mango, *Art of the Byzantine Empire* (as in Chapter 4), 161-5.

For the **monastery of Gastria**, see Janin, *Les églises et les monastères* (as in Chapter 5), 67-8; for St Panteleimon and Alexios' monastery, see Thomas, *Private Religious Foundations* (as in Chapter 5), 132-3. On female monasticism during iconoclasm, see further J. Herrin, 'Changing functions of monasteries for women during Byzantine Iconoclasm', in L. Garland (ed.), *Byzantine Women: varieties of experience 800-1200* (Aldershot, 2006), 1-15.

On **Byzantine organs**, see J. Herrin, 'Constantinople, Rome and the Franks in the seventh and eighth centuries', in J. Shepard and S. Franklin (eds), *Byzantine Diplomacy* (Aldershot, 1992), 91-107. On the **automata and the *Pentapyrgion***, see G. Brett, 'The automata in the Byzantine "Throne of Solomon"', *Speculum* 29 (1954), 477-87; Magdalino, 'The road to Baghdad' (as above); G. Dagron, 'Architecture d'intérieur: le Pentapyrgion', in F. Baratte, V. Déroche, C. Jolivet-Lévy and B. Pitarakis (eds), *Mélanges Jean-Pierre Sodini = Travaux et mémoires* 15 (2005), 109-17.

On **monks and saints of the iconoclast era**, see I. Ševčenko, 'Hagiography of the iconoclast period', in Bryer and Herrin (eds),

I*conoclasm* (as above), 113-31; R. Morris, *Monks and Laymen in Byzantium 843-1118* (Cambridge, 1995); P. Hatlie, *The Monks and Monasteries of Constantinople c. 358-850* (Cambridge, 2007); and for a **collection of saints' lives in translation** A.-M. Talbot (ed.), *Byzantine Defenders of Images: eight saints' lives in English translation* (Washington DC, 1998).

For information on the **buildings** of

Ioannikios, see C. Mango, 'The two lives of St Ioannikios and the Bulgarians', in C. Mango and O. Pritsak (eds), Okeanos: essays presented to Ihor Sevcenko on his sixtieth birthday, *Harvard Ukranian Studies* 7 (Cambridge, 1983), 393-404.

Makarios, see Janin, *Les églises et les monastères des grands centres byzantins* (as in Chapter 4), 200; Ruggieri, *Byzantine Religious Architecture* (as in Chapter 5), 206.

Symeon of Lesbos: the relevant *Life* appears in English tr. in Talbot, *Byzantine Defenders of Images* (as above), 149-241, for the monastery see esp. 205.

Niketas, see *Thomas, Private Religious Foundations* (as in Chapter 5), 132.

Ignatios, see Janin, *Les églises et les monastères des grands centres byzantins* (as in Chapter 4), 61-3, 65, 67; Ruggieri, *Byzantine Religious Architecture* (as in Chapter 5), 209.

For **Anna's building**, see A. Kazhdan and A.-M. Talbot, 'Women and iconoclasm', *Byzantinische Zeitschrift* 84/5 (1991/2), 391-408, at 398; repr. in Talbot, *Women and Religious Life in Byzantium* (Aldershot, 2001), study 3.

On **Kassia's monastery**, see Janin, *Les églises et les monastères* (as in Chapter 5), 102; on **Kassia** herself, A. Silvas, 'Kassia the nun *c.* 810-*c.* 865: an appreciation', in L. Garland (ed.), *Byzantine Women: varieties of experience 800-1200* (Aldershot, 2006), 17-39 should be read with extreme caution.

7

The 'triumph of orthodoxy' and the impact of the image crisis

Theophilos died on 20 January 842. His son, Michael III, had been crowned co-ruler as an infant, and turned two the day before Theophilos' death. Theophilos' widow Theodora thus became regent, joined by the eunuch Theoktistos, whom Theophilos had appointed to assist Theodora after his death. Theodora and Theoktistos remained in power as regents until Michael turned 16, the age at which a Byzantine male was felt to have matured. (Shortly thereafter, in March 856, Michael III, with the assistance of his uncle Bardas, deposed his mother, and had her close ally Theoktistos assassinated: but that is part of a different story.)

Theodora, Michael III, Methodios and the synod of 843: Just over a year after Theophilos' death, the synod of 843 officially ended the image struggle by restoring the veneration of holy images. We know little about how the groundwork for the meeting was set other than that the preparations appear to have been managed by Theoktistos. Later authors sought to make the 'triumph of Orthodoxy' appear to have been inevitable, and claimed that Theodora secretly venerated icons in the palace and was thus predisposed to sponsor a change to the pro-image position. This, however, finds no corroboration in ninth-century sources or even in the (also later) hagiographical *Life* of Theodora. Nor, with one exception, were any of the men involved in the preparations for the synod known supporters of images while Theophilos was still living: certainly Theoktistos actively supported Theophilos' iconoclast position during his lifetime. The exception is Methodios, who, as we saw in the last chapter, was sent into exile (in 821, before Theophilos came to the throne) for his pro-image rhetoric, but – if the *Life* of Methodios is

to be believed – spent the last five years of Theophilos' reign in the palace, sparring with the emperor. His precise role in the decision to revoke the iconoclast policies in place since 815 is, however, unclear: most sources, as just noted, place more emphasis on the role played by the formerly staunch iconoclast Theoktistos. Under these circumstances, it seems most likely that the move was as pragmatic as it was theological. The rhetoric of the synod itself suggests that one major aim was to restore harmony amongst the ruling elite, as usual at the expense of the losing side. The shift in policy might also have been intended to secure the power-base of Theodora and Theoktistos who, with a small child as emperor, may have felt the need of a firm 'new' policy to provide a focus for, and consolidate, their positions as regents. But the pro-image position also had one distinct advantage over the anti-image side. As we saw in Chapter 4, through their emphasis on texts and their insistence that only the clergy could mediate between the earthly and the spiritual realm, the iconoclasts restricted access to divine mediation to a limited few. In sharp contrast, by promoting the real presence of holy portraits and the compulsory veneration of them, the pro-image faction in 787 legitimised open access to God for all Orthodox believers. The belief that the real presence of saints could be accessed through their portraits was also, as we saw in Chapter 2, one that emerged from the practice of ordinary people rather than a system imposed by the upper echelons of the church, which presumably, in the end, made it easier to administer. But however the arguments in the regency court of Theodora and Theoktistos ran, Theodora made it abundantly clear that Theophilos was not to be condemned posthumously – indeed the Continuator of Theophanes, whom we met in Chapter 6, claimed that 'if this [the non-condemnation of Theophilos] is not granted, she will not grant them restoration of icons nor the direction of the church'.

In any event, preliminary meetings to plan the change seem to have been organised by and for members of the court, and apparently took place in the home of Theoktistos. The synod itself was held at the Blachernai palace in early March 843. It confirmed the *Acts* of the 787 council at Nikaia, but, as required by Theodora, did not list Theophilos among the heretical iconoclasts condemned at the end of the document. Methodios was appointed as patriarch, and John the Grammarian resigned. The sources record no opposition, although 26 years later, in 869, five more

7. The 'triumph of orthodoxy' and the impact of the image crisis

iconoclasts were condemned, which suggests that remnants of anti-image support lingered. The official era of Byzantine 'iconoclasm' was, however, over, this time for ever; and the 'Triumph of Orthodoxy' has been celebrated on the first Sunday of Lent (the Sunday of Orthodoxy) in the Orthodox church ever since.

Representation and register: theology and practice

Representation is a key aspect of the image debates. This is not because the Byzantines were concerned about how to portray holy people (though they sometimes did worry about this), but because they were anxious to define the limits of what representation could show and mean. Over the course of the eighth and ninth centuries, many erudite churchmen – perhaps most notably the patriarchs Germanos (whom we met in Chapter 3), Nikephoros (whom we met in Chapter 5) and Photios (858-67, 877-86); and the monks John of Damascus (c. 675-749) and Theodore of Stoudios (whom we also met in Chapter 5) – and the emperor Constantine V wrote about issues of representation at considerable length. All were quite clear on the distinction between different types of representation, and all but Constantine V applied them carefully to build a theology of icons that justified the role of sacred portraits in Orthodox Christian worship.

Icons in theory: the theology of icons: The theology of icons that developed in the eighth and ninth centuries had two main tenets. First, as we saw in Chapter 5, the incarnation (Christ's appearance on earth) was the fundamental justification of religious portraiture. Christ's visibility demonstrated that both his human and divine natures, co-mingled as they were in his lifetime, could be seen by mere mortals, and hence depicted in paint, mosaics or ivory. Second, portraits re-present the person shown, they are not the same as that person – or, as the Byzantines put it, the image does not share the essence of the person portrayed. This is why Byzantine theologians stressed that the image was distinct from its subject and could not be confused with it. An icon is not, therefore, an idol; it remains very much a representation of a being, the original of which is in heaven. The churchmen maintained that icons were 'truthful' precisely because they were manufactured and did not

pretend to be identical with their subject. We are assured by pro-image Byzantine theologians that the painter (or mosaicist, or ivory carver) was inspired by God to recreate a likeness of the original saint (or Christ, or the Virgin), a belief underscored by tales of painters inspired by visions from God that told them how to portray a particular saint.

From this it follows that, in the theology (or theory) of icons, the picture itself has been stripped of the 'real presence' that we saw emerging in the late seventh century and that made religious portraits so powerful and important that they prompted the iconoclast reaction against them. The 'theological' icon is an artefact, a piece of (say) wood painted with a portrait that the faithful Christian contemplates as she or he prays. Does this mean that the iconoclasts won, after all? The answer to this rhetorical question is no, and the reason for this has to do with the difference between theory (the theology of icons) and practice. The theology of icons that was developed during the eighth and ninth centuries was an important and new component of the intellectual and ecclesiastical history of the Byzantine Empire. It did not, however, have much direct impact on the social history of Byzantium (how people acted), and less influence on the cultural history of Byzantium (what Byzantines wrote about and depicted in images) than one might imagine.

This is because the theology of icons did not inspire new practice, it justified and codified practices that had begun earlier (as we saw in Chapters 2 and 3), in the seventh century. Theology, in other words, is not why iconoclasm happened. In 691/2, canons 73, 82 and 100 of the Quinisext council responded to the new role of the sacred portrait; in 787, the seventh ecumenical council (Nikaia II) provided a theological justification for it that was elaborated by churchmen writing in other venues as well. Both the seventh- and the eighth-century responses followed, and attempted to regulate, changes in social and cultural practice. By regulating and systematising the role of sacred portraits in the Orthodox church, eighth- and ninth-century theologians created the cult of icons, but they did not create the desire to access the holy in a new way: they vindicated and codified existing realities. Theory (theology) followed practice.

Canon 100 of the Quinisext council hints at how this process worked. As we saw in Chapter 2, canon 100 ordered that 'things which incite pleasures are not to be portrayed on panels'. This is part of the council's

7. The 'triumph of orthodoxy' and the impact of the image crisis

effort to purify the church of irregular practices, but as importantly it represents the first attempt of the church to control sacred imagery, and to ensure that the newly powerful images were painted in an Orthodox manner. The late seventh-century churchmen did not know quite how to explain what 'good' painting was: but they gamely responded to (and tried to control) changes in practice. Canon 100 shows us that the Quinisext churchmen knew that the significance of representation had changed, that they wanted to make certain that religious representation remained Orthodox, and that the church retained a level of control over it.

This desire was only partially fulfilled, for the honour that was given to holy portraits was, as the churchmen correctly insisted, directed at the saint portrayed, and the distinction between the image of the saint and the saint him- or herself was thus easily blurred. This was brought out sharply by the contrast between the theology of learned churchmen and the response to images considered appropriate in accounts of people in everyday situations.

Icons in practice: Around the year 690, Anastasios of Sinai wrote a treatise against demons (*Diēgēmata stēriktika*). The second story in the text concerns a portrait of St Theodore in a church just outside of Damascus occupied by Saracens (Muslims): one of the Saracens attacked the icon with his lance, and it bled, after which all twenty-nine Saracens died. The bleeding icon is a familiar theme in iconophile writings, and I cite it here to make the point that as soon as we leave the rarified atmosphere of learned theological treatises, the properties of the sacred portrait so carefully distinguished by Byzantine churchmen collapse. This is true not only of 'popular' literature such as saints' lives and miracle accounts, but also of non-theological texts written by the same elevated churchmen who were careful to maintain the distinction between image and saint when writing icon theory. Theodore of Stoudios, for example, was fully aware of the relative relationship between a portrait and the person portrayed that we have just noted; nonetheless, when writing a letter to the *spatharios* John (a court dignitary), Theodore praised him for replacing a human godfather with an icon of St Demetrios for 'here the bodily image took the place of its model' and 'the great martyr was spiritually present in his own image and so received the infant'. Godparents were important in the Byzantine world, and as far as John was concerned,

the icon of Demetrios – not St Demetrios acting through his portrait, but the icon itself – had enough real presence to act as godfather to his son; Theodore of Stoudios, a stickler for Orthodox practice (as we have seen), heartily endorsed this belief.

Context is obviously important here: theological tracts and church legislation require official language and the careful formulation of image theory, while letters to friends can be more casual. But the discrepancy between the theological appreciation of a sacred portrait ('true' because it is manufactured, and not the same as the saint) and the day-to-day acceptance of the same image (as a material stand-in for the saint) is not only about different registers of response: it is also about different understandings of representation.

For it is clear that, to Theodore of Stoudios, an icon of St Demetrios could be a manufactured artefact, differentiated from the saint, and sharing with Demetrios only likeness, not essence and at the same time a manifestation of the saint, standing in for the real Demetrios, who is 'spiritually present in his own image'. Byzantine theological understanding of the icon as a manufactured panel painting prevented icons from being idols; Byzantine understanding of the icon as embodying the real presence of the saint allowed the faithful to kiss it when they entered a church, and in this role icons became an enduring facet of Orthodox self-identity. The manufactured, theological icon is not a transparent window through which the faithful see the real saint, but is instead, to quote Charles Barber, 'a signpost whose insistent presence directs us elsewhere': the appropriate Orthodox response to the theological icon was (and is) contemplation. The icon as an embodiment of real presence is a window leading to the saint depicted: the appropriate Orthodox response to this understanding of the icon was (and is) veneration, kissing or even, as we have just seen, installing it as a godfather.

The belief in sacred portraits as intermediaries between humans on earth and the divine did not need this dual understanding of representation, it only required the second, a belief in the icon as real presence. The desire for new and improved access to the holy was, as we have seen, a product of the ongoing crises of the seventh century. But, as at least some churchmen were swift to appreciate, accepting real presence in icons had the potential to unleash unrestrained rights of access to the sacred, for icons – unlike relics – were infinitely reproducible. The

7. The 'triumph of orthodoxy' and the impact of the image crisis

Quinisext council began the process of regulating Orthodox imagery, but it was really only after the iconoclast backlash instigated by Thomas of Klaudioupolis and Constantine of Nakoleia in the 720s, and especially in the early ninth century, that rules and regulations – the theology of icons – were fully developed, and the theological icon was born. As we have just seen, however, icon veneration was led by practice, not theory, and so the theological understanding of the icon, sophisticated as it is, was never the primary force of the holy portrait in the Byzantine world.

References

For the **quotation from the Continuator of Theophanes** (p. 108) see *Theophanes Continuatus* (as in Chapter 6), 152; discussion in Karlin-Hayter, 'Icon veneration' (as in Chapter 6), 181-2.

For **Anastasios of Sinai's tale of the bleeding icon** (Miracle B.2) noted on p. 111: see B. Flusin, 'Démons et sarrasins. L'auteur et le propos des Diègèmata stèriktika d'Anastase le Sinaïte', *Travaux et Mémoires* 11 (1991), 380-409. It has been argued that this passage was added in the ninth century, but the precise date of the story does not affect the argument made here.

For **Theodore of Stoudios' letter** (p. 111) see Fatouros (as in Chapter 4), I, 17; English tr. in Mango, *Art of the Byzantine Empire* (as in Chapter 4), 174-5.

For the **quotation from Charles Barber** (p. 112) see his *Figure and Likeness: on the limits of representation in Byzantine iconoclasm* (Princeton NJ, 2002), 137.

Bibliography

On the (unsubstantiated) claim that **Theodora secretly venerated icons**, see M. Vinson, 'Gender and politics in the post-iconoclastic period: the lives of Antony the Younger, the empress Theodora, and the patriarch Ignatios', *Byzantion* 68 (1998), 469-515. For an English tr. of the *Life*, see Talbot (ed.), *Byzantine Defenders of Images: eight saints' lives in English translation* (as in Chapter 6), 353-82.

On **Methodios**, see the references in Chapter 6.

The **Sunday of Orthodoxy** was fully established only at the end of

the ninth century: see J. Gouillard (ed.), 'Le synodikon de l'orthodoxie, edition et commentaire', *Travaux et Mémoires* 2 (1967), 1-316.

For **Theodora and Theophilos**, see A. Markopoulos, 'The rehabilitation of the emperor Theophilos', in Brubaker (ed.), *Byzantium in the Ninth Century* (as in Chapter 6), 37-49, and Karlin-Hayter, 'Icon veneration' (as in Chapter 6), 181-2.

There are a handful of English translations of the major Byzantine writings on images: for **John of Damascus** see D. Anderson, *St John of Damascus, On the Divine Images, Three Apologies Against Those Who Attack the Divine Images* (Crestwood NY, 1980); for **Theodore of Stoudios** see C. Roth, *St Theodore the Studite, On the Holy Icons* (Crestwood NY, 1981); and for **Photios** see C. Mango, *The Homilies of Photius, Patriarch of Constantinople*, Dumbarton Oaks Studies 3 (Washington DC, 1958). For a French translation of one text by **Nikephoros** see Mondzain-Baudinet, *Discourse contre les iconoclasts* (as in Chapter 4). For discussion of the main lines of argument, see Alexander, *The Patriarch Nicephorus of Constantinople* (as in Chapter 5); L. Brubaker, 'Byzantine art in the ninth century: theory, practice, and culture', *Byzantine and Modern Greek Studies* 13 (1989), 23-93.

For an excellent overview of the **theology of icons**, see Barber, *Figure and Likeness* (as above; and 122-3 for Byzantine discussions of how icons share likeness but not essence with their heavenly counterparts); K. Parry, 'Theodore Studites and the Patriarch Nicephoros on image-making as a Christian imperative', *Byzantion* 59 (1989), 164-83; and K. Parry, *Depicting the Word: Byzantine iconophile thought of the eighth and ninth centuries*, The Medieval Mediterranean 12 (Leiden, 1996) are also valuable.

8

Conclusions: the impact of iconomachy and the invention of 'iconoclasm'

Iconomachy, the Byzantine struggle about images, was generated by changes in the ways ordinary people responded to portraits of holy people, and it ultimately changed the way Orthodox Christian theology dealt with icons. The belief that portraits of saints had real presence, just as relics did, is documented in tales about everyday life and in anti-heretical texts by the end of the seventh century, as we saw in Chapter 2. The reaction against this belief – what we call iconoclasm – backfired, and instead of ending icon veneration it resulted in the embedding of the rituals surrounding icons in the canonical laws of the Orthodox church, thus perpetuating the reverence of icons to this day. Iconoclasts hoped to end icon veneration; instead their actions ensured that the practice was strengthened and spread by the institutional church. Responding to pressure from below, the church at Nikaia in 787, and then again in 843, sanctified practice by legitimising the veneration of holy portraits, expressed by bowing before them, kissing them, and honouring them with lights and the burning of incense.

This is a very significant shift, but the main change occurred before, and generated, the image struggle ('iconoclasm') itself, as we have seen. The impact of iconoclasm on devotional practice was, essentially, simply to legitimate it in the eyes of the official church. This had precisely the opposite effect of what the iconoclasts had intended, for it actively encouraged the spread of the practice of icon veneration. What was the impact of the image struggle on the liturgy and artisanal production?

The impact of the image struggle on Orthodox liturgy and artisanal production

After 843, icons were freely displayed in churches across the Orthodox world, and eventually also covered the iconostasis, a wall-like screen set up between the apse of the church (where the altar was housed) and the main body of the building where the worshippers stood. Yet the role of icons in Orthodox church or monastic liturgical services was limited. Not surprisingly, icons seem to have been the focus of attention during the services for the annual Sunday of Orthodoxy that celebrated the ending of the image struggle in 843. An icon of the Virgin was also the focus of what appears to have been a regular Friday night service at the Blachernai church in Constantinople. But there is little other indication that icons were treated specially in Orthodox liturgical services in the Byzantine Empire. In churches (and in homes) icons, on the whole, continued as they began: vehicles for individual communion with the saint portrayed.

The predominant public role of icons in the Byzantine period – if we may trust the written and visual sources – was as the focus of processions. As we saw in Chapter 2, icons were paraded around the walls of cities in solemn processions to protect the inhabitants from danger from at least the sixth century onward. This practice certainly continued after 843, and icons continued to lead many additional urban processions as well, from imperial victory parades to demonstrations organised by municipal guilds.

Artisanal production: The impact of the image debates on artisanal production is on one level straightforward. The official ecclesiastical status of holy portraits meant that they became appropriate donations for the faithful to present to churches and monasteries, and richly decorated icons – icons carved of ivory, cast in precious metals or enamelled, and encrusted with gems – appeared, along with precious frames and partial coverings for particularly effective miracle-producing icons. As icons became more numerous (and valuable) their subject matter also expanded and, in addition to icons of individual saints, images of the great liturgical feasts of the Orthodox year (for example, the Nativity for Christmas or the Crucifixion for Easter) and icons celebrating the

8. Conclusions: the impact of iconomachy and the invention of 'iconoclasm'

achievements of individual saints or groups of saints became increasingly common.

Beyond the proliferation and elaboration of icons themselves, however, three additional features of post-iconoclast artisanal production are worth signalling here. First, the physiognomic attributes of individual saints became regularised. Because the portrait stood in for the saint, it had to be an accurate depiction of what that saint was believed to look like. Originality was not acceptable here, because the viewer needed to know instantly which saint she or he confronted; the ideal was for each portrait of, say, St George, to look the same as other portraits of St George. Second, religious images were no longer considered appropriate for casual domestic decoration, such as on clothing. Because holy portraits represented the real presence of the saints, it was clearly not acceptable, for example, to drag them along in the mud, as one would if they were embroidered into the hem of one's garment. Increasing decorum and etiquette came to surround the sacred portrait in many small ways, alongside the larger trappings of lights and incense. Third, the holy figures portrayed were now virtually always accompanied by an identifying inscription, telling the viewer their names. Clarity and accuracy had become essential, and the visual precision of the portrait was underscored by also naming the saint pictured. We do not know what the level of illiteracy was in Byzantium (probably high), but just as people visiting countries that use a script quite unlike their own (say, an English-speaker in Japan) can often learn quite easily to 'read' some of what looks to them like pictograms, it is quite possible that even the least learned Byzantines knew that an icon of Demetrios was legitimate because it not only looked like Demetrios looked, but had his recognisable name written alongside the saint as well.

Women and icons

It is often supposed that women were particularly attached to images. There are two reasons for this hypothesis, one based on outdated and misplaced assumptions, the other on the belief that Byzantine women had few religious outlets other than icon veneration. Neither is supported by any but the most tenuous evidence.

There is a long tradition in western historical thought that images are

valuable didactic tools for the illiterate. This was expressed as early as the sixth century by pope Gregory the Great, and remained a standard tenet of western Christian thought throughout the Middle Ages. It was never, however, the dominant tradition in Byzantium, which – as we have seen throughout this book – favoured visual evidence and, from the late seventh century onwards, believed that images of saints could be invested with their real presence. In the western, Catholic Middle Ages, images were considered particularly useful tools to teach novices and women, but, there is no evidence for such a divide in the Orthodox church. The Catholic European mind-set was, however, somewhat paradoxically applied to Byzantium by Edward Gibbon, in his influential *Decline and Fall of the Roman Empire*, a key text of the 'Enlightenment' of the eighteenth century. Gibbon, like many Enlightenment authors, was fiercely anti-clerical, and opposed to what he saw as the idolatry of the Catholic church; he also – again, like many Enlightenment authors – had scant regard for female intellect. These attitudes came together in his evaluation of the Byzantine iconoclast period, where he claimed that 'The idols ... were secretly cherished by the order and sex most prone to devotion; and the fond alliance of the monks and females obtained a final victory over the reason and authority of man'. Gibbon cites no evidence, though we may assume that his indictment of women as idolaters stemmed from the restoration of image veneration in 787 during the regency of Eirene and in 843 during the regency of Theodora. As we have seen, there is no contemporary evidence that either empress was 'secretly' pro-image, nor that their religious sentiments were the main focus of either the 787 council or the 842 synod. As we have also seen, except for the Stoudite monks under Theodore's leadership, there is no evidence that monks, as a group, were particularly pro-image. We must, in the end, discount any association of women (with or without monks) and icons based on either a false analogy with the Catholic tradition, on the one hand, or the anti-clerical and anti-female attitudes of the Enlightenment, on the other.

The other argument used to associate women and icons is based on the perceived difficulties of female access to, and participation in, official religious life. Because women could not be priests, and were increasingly denied 'official' roles in the Orthodox church, it has been argued that they probably sought outlets for their spirituality in the more intimate

8. Conclusions: the impact of iconomachy and the invention of 'iconoclasm'

and private realm of icon veneration. While this is possible, there is little evidence to support this belief, and the dividing line between private and public is a modern construct without much relevance to the pre-industrial world. It is certainly true that Byzantine women had less opportunity for official public roles than did their male counterparts, and that the idealised female found in Byzantine texts usually appears in domestic settings. But to judge by the letters of Theodore of Stoudios, the role of women in the church was reasonably robust in the first half of the ninth century. Theodore had a wide range of female correspondents – 76 of his 564 preserved letters were addressed to forty different women – most of whom actively supported his pro-image position even, in two cases, when their husband or brother-in-law (both members of the imperial administration, whose job security presumably depended on their 'correct' political views) did not. Women clearly had views about images, and those who were in communication with Theodore were, inevitably, in favour of icon veneration, just as were the great majority of his male correspondents. But one does not get the impression from Theodore's letters, or any other source, that women were particularly likely to be *especially* attached to icons. Later evidence for, say, street processions honouring icons list both men and women among the important participants, which suggests that women were able to assume at least quasi-official roles in religious ceremonies and that they worked alongside men in this capacity.

We have also seen, however, that in their literary re-invention of the image struggle, Byzantine authors themselves sometimes associated women and icons. The *Life* of St Stephen placed women at the forefront of the probably fictional Chalke gate incident; and, without any apparent justification, later texts associated Eirene and Theodora with secret image veneration. For male, pro-image authors, women were clearly a useful rhetorical device to set in opposition to what was portrayed as impious and heretical male behaviour. These stories reveal a lot about the construction of gendered roles in the Byzantine world, but they are hardly reliable reports of anything that actually occurred. They form part of a larger arsenal of texts generated to promote a particular view of the Byzantine image struggle, to which we shall now turn.

The invention of 'iconoclasm'

As we saw at the beginning of this book, the term 'iconoclasm' was not coined until after the fall of the Byzantine Empire. It appeared in Latin in 1571; and in English only in 1797, during the French Revolution. Its first application to Byzantine iconomachy appeared in the 1950s, since when its use has increased exponentially: over 100 articles or books on Byzantium included the word in their titles during the first decade of the twenty-first century.

But long before that, the beliefs that form the basis of most modern understandings of Byzantine 'iconoclasm' had already been formed. How did this happen?

Byzantine official concern with images began with the Quinisext council of 691/2, and the victorious pro-image faction continued actively to denounce its opponents for a good generation after the 'Triumph of Orthodoxy' in 843: the sometime patriarch Photios (858-67, 877-86), for example, was still condemning iconoclasts in sermons of the 860s, though this was probably largely as a means of self-promotion since his family – unlike that of his rival, the sometime patriarch Ignatios (847-58, 867-77) – had apparently been unwavering in its support of images, even under hostile emperors. Across the relatively long period of, more or less, 200 years that images were a focus of debate, however, only the years between 754 and 787 and between 815 and 843 were 'officially' iconoclast and, of these, only about 30 saw the active persecution of members of the pro-image faction. So while the social and cultural changes were deep-rooted, and remain embedded in Orthodox practice, the image debate rarely had any disruptive impact on the day-to-day lives of the Byzantines; and even when it did, this was apparently only really discernable in the capital.

Why, then, has modern scholarship painted the Byzantine image debates as a long period of intense and bitter upheaval, championed by dogmatic emperors and marked by rampant destruction of images? Why, when, and how was 'iconoclasm' invented?

As we have already seen, the Byzantines began re-writing the history of the image struggle already by about the year 800, when the legend of Leo III's purported destruction of an image of Christ above the Chalke

8. Conclusions: the impact of iconomachy and the invention of 'iconoclasm'

Gate was invented. Byzantine re-invention of the past was not, it must be emphasised, necessarily conscious: like everyone else, the Byzantines tried to explain the past in terms that made sense in the present, and to reconstruct the historical narrative in ways that led sensibly to the present in which they lived. Some of the rewriting of the past was, however, part of a determined campaign aimed at vilifying the Isaurian dynasty inaugurated by Leo III in 717. In its early phases, this was simply a means of neutralising the achievements of Leo III and, especially, Constantine V, who had masterminded the administrative and military reorganisation that resulted in the restoration of state stability, and had engineered the revival of empire after the disasters of the seventh century. By the mid-ninth century, it had moved beyond this into a wholesale denunciation of selected members of the Isaurian dynasty by promoters of the new Makedonian dynasty. The main vehicles of the anti-iconoclast campaign were histories and saints' lives, which, following the pattern of early Christian martyr stories, recast members of the pro-image faction as Christian martyrs and their opponents as heretical oppressors equivalent to the pagan persecutors of early Christians. The success of these literary inventions is clear from their repetition ever since, both by the Byzantines (especially during the twelfth-century 'reforms' of the church) and in modern scholarship.

Lazaros the painter provides an excellent case study of how this process worked. Lazaros is a man shrouded in iconophile rhetoric whose legendary artisanal production cannot easily be translated into any actual artefacts. The only contemporary references to him are from Rome: they appear in the *Book of the Popes* and a letter of pope Nicholas I. Here we learn that Lazaros was a monk 'very well trained in the painter's skill' who presented gifts from the emperor Michael III to the pope in 857/8. In the early tenth century, his life was summarised in the *Synaxarion* of Constantinople (a collection of short saintly biographies), which agrees that Lazaros was a monk and a painter, and adds that he was persecuted for his pro-image beliefs during the reign of Theophilos. The fullest version of his activities appeared in the mid-tenth century account of the Continuator of Theophanes. Here it is claimed that Lazaros was 'famous for the art of painting', and was 'widely believed to have died' from the torture Theophilos had inflicted upon him for this fame; he had 'barely

recovered in prison, [before he] took up his art again and represented images of saints on panels'. Theophilos therefore 'gave orders that sheets of red-hot iron should be applied to the palms of his hands'. This almost killed him, but then, 'thanks to the supplication of the empress [Theodora] and some of his closer associates', Theophilos released Lazaros from prison and he went to the church of John the Baptist in Phoberou (on the Asiatic shore of the Bosphoros); here, according to the Continuator, he painted an image of John the Baptist that later performed 'many cures' (the exact nature of which is unspecified). The Continuator also credits Lazaros with a portrait of Christ set up in or after 843 on the Chalke Gate leading into the imperial palace – a replacement for the one by then believed to have been initially removed by Leo III. What we see here is the gradual accretion of details. Lazaros starts as a well-trained painter and monk of, evidently, some status as Michael III sent him to Rome. By the early (?) tenth century, when the *Synaxarion* was compiled, he is said to have been persecuted; and by the mid-tenth-century account of the Continuator, Lazaros has become the focus of Theophilos' rage and Theodora's pity. The Continuator's account is impossible – in the days before advanced reconstructive surgery, no one whose hands have been severely burnt could ever paint well again; Theodora, as we have seen, is unlikely to have intervened with her husband on a monk's account – but the accuracy or not of the Continuator's story about Lazaros is hardly the point. Whatever he actually did, Lazaros did not die for the iconophile cause. Instead, he became a symbol of resistance, a martyr to the emperor's unbalanced anger and heretical beliefs (neatly foiled by his pious wife), and a focus for later accounts of iconophile activity, as is clear from pilgrim accounts of Hagia Sophia as late as the thirteenth century, where Lazaros is (erroneously) named as the creator of the apse mosaic dedicated by the patriarch Photios in the presence of Michael III and Basil I in 867.

Lazaros provides an excellent example of how the Byzantines themselves moulded and rewrote their own history. And his case also shows us how influential Byzantine spin has remained: in her 1977 facsimile of the famous Khludov Psalter, dating to *c.* 843-847, M.B. Ščepkina – citing no evidence at all – attributed its miniatures to him, apparently purely on the basis of her interpretation of the Continuator's story.

Byzantine painters also helped re-visualise the struggle. A case in

8. Conclusions: the impact of iconomachy and the invention of 'iconoclasm'

Fig. 26. Crucifixion and iconoclasts whitewashing an image of Christ.

point is provided by one of the best known images from the Byzantine world, the miniature of the crucifixion of Christ in the manuscript just mentioned, the Khludov Psalter (Fig. 26). Here we see the crucifixion of Christ above an image of iconoclasts whitewashing an image of Christ.

The pictures accompany Psalm 68, which does not describe either event. Verse 22, however, prompted the upper scene. It reads: 'They gave me also gall for my food, and made me drink vinegar for my thirst'. This reminded Byzantine commentators of Christ's crucifixion, as described in the New Testament, and the miniaturist tied the image more closely to the text by including Christ's tormentors, one of whom offers him the sponge soaked in vinegar and gall described in the Gospels, and writing next to them 'they [mixed] vinegar and gall', thus verbally tying together the Old Testament psalm verse and the New Testament image. The lower scene, showing two figures labelled as iconoclasts whitewashing a circular portrait of Christ (having dipped their sponge into a jug identical to the jug of vinegar next to Christ's cross), visually equates iconoclasts with Christ's tormenters as he died on the cross. This is confirmed by the text next to the two figures, which reads 'and they mixed water and lime on his face'. The point visualised here was expressed in a slightly earlier anti-iconoclast broadsheet as 'formerly the impious put to the lips of Jesus a mixture of vinegar and gall; in our day, mixing water and lime and fixing a sponge to a pole, they applied it to the icon and besmeared it'. As we have seen, there is actually very little evidence that members of the anti-image faction destroyed (or whitewashed) images, but the miniature in the Khludov Psalter is part of the rewriting – or, in this case, re-painting – of the past: the winners re-presented history in a way that makes the losers look particularly dreadful. The renown of this particular image indicates just how successful the winners were in influencing future beliefs.

Other iconoclasms

Byzantine iconoclasm and the Islamic prohibition against images have often been compared, and some scholars have attempted to show that the Byzantine anti-image position was influenced by the Muslim rejection of figural representation. This argument cannot be sustained. Islamic beliefs about images are not found in the Qu'ran, but in the hadith, collections of sayings attributed to Mohammed and his circle that are notoriously hard to date. Whenever Islamic thoughts about images were codified, however, they differ fundamentally from Byzantine views. Islam rejected representation of any living creature, human or animal;

8. Conclusions: the impact of iconomachy and the invention of 'iconoclasm'

Byzantine iconoclasts rejected representation of holy people only. It is perfectly true that Orthodox Christianity focussed on the role of images at the same time as Islam became the dominant religion of much of the former East Roman Empire, but, as we saw in Chapter 2, that had nothing to do with Byzantium 'copying' Islamic belief.

On one level, more modern iconoclasms – from that practiced during the Reformation and the French Revolution to that advocated by the modern Taliban – have equally little in common with Byzantine iconomachy, because they all involve the active destruction of cult objects, which the Byzantines very seldom engaged in. On another level, however, they share common ground, in that all accept the power of images, and use words about images to make points about society. This last role has raised questions about whether images are 'really' the point of such contestations at all: were statues destroyed by agents of the Reformation/French Revolution/Taliban because they were believed to be inherently evil, or in order to make a broader political statement? This is hardly the place to consider such a broad question, but I would like to conclude this book by asking how significant icons were to Byzantine iconomachy.

Was 'iconoclasm' about icons?

Yes. Byzantine iconomachy was, centrally and crucially, about the potential power of sacred images. How a material object could be invested with the real presence of a saint was a philosophical question that had already been resolved by the cult of relics. Expanding the real presence of a saint from relics to relic-icons and thence to icons, a process traced in Chapter 2, increased human ability to interact with the holy in real and – in the context of the late seventh century – much needed ways. Increased human access to Christ, the Virgin and the saints was available through icons from *c.* 680 onwards, and it was the backlash against this that led to iconomachy. Whatever other issues played themselves out during the course of the debate, the fundamental concern remained mediation, through a manufactured image, between the terrestrial and the celestial. Talk about icons can also be about many other things, as I hope has become clear during the course of this book: images are good to think with. But at heart 'iconoclasm' was about representation, about the power of the visual in the lives of Orthodox Christians, and about

how the visual in the form of icons allowed all people in the Orthodox world to interact with God and God's representatives without having to negotiate the hierarchy of the official church. Iconoclasm by any name would not, and could not, have occurred without icons.

References

The **quotation from Gibbon** (p. 118) is taken from his *The Decline and Fall of the Roman Empire* 3, ed. J. Bury (New York, 1964), 1692. This influential work, in six volumes, originally appeared between 1776 and 1789.

For the passages on **Lazaros the painter** (p. 122) see Duchesne (ed.), *Liber Pontificalis* 2 (as in Chapter 3), 147 with an English translation in R. Davis, *The Lives of the ninth-century Popes (Liber Pontificalis)*, Translated Texts for Historians 20 (Liverpool, 1995), 186; *Theophanes Continuatus, Chronographia* (as in Chapter 6), 102-3; translated into English in Mango, *Art of the Byzantine Empire* (as in Chapter 4), 159. Discussion in C. Mango and E.J.W. Hawkins, 'The apse mosaics of St Sophia at Istanbul. Report on work carried out in 1964', *Dumbarton Oaks Papers* 19 (1965), 115-51, at 144-5. For the Khludov Psalter, see M.B. Ščepkina, *Miniaturi Khludovskoi Psalt'iri* (Moscow, 1977) and K. Corrigan, *Visual polemics in the Ninth-century Byzantine Psalters* (Cambridge, 1992).

Bibliography

On the **iconostasis**, see the essays collected in S. Gerstel (ed.), *Thresholds of the Sacred* (Washington DC, 2006).

On **icons in the liturgy and in procession** see N. Patterson Ševčenko, 'Icons in the liturgy', *Dumbarton Oaks Papers* 45 (1991), 45-57.

On **guilds and icons** see J. Nesbitt and J. Wiita, 'A confraternity of the Comnenian era', *Byzantinische Zeitschrift* 69 (1975), 360-84.

On **icons as gifts and commodities**, see N. Oikonomides, 'The holy icon as asset', *Dumbarton Oaks Papers* 45 (1991), 35-44. On Byzantine sensual **appreciation of the material of icons**, see B. Pentcheva, 'The performative icon', *Art Bulletin* 88 (2006), 631-55. For a good, brief **overview of icons** across the entire Byzantine period, see K. Weitzmann, *The Icon* (New York, 1978).

8. Conclusions: the impact of iconomachy and the invention of 'iconoclasm'

On **'originality' in Byzantine artisanal production**, see G. Vikan, 'Ruminations on edible icons: originals and copies in the art of Byzantium', *Studies in the History of Art* 20 (1989), 47-59.

On **changes in post-iconoclastic artisanal production**, see H. Maguire, *The Icons of their Bodies: saints and their images in Byzantium* (Princeton, 1996), esp. 100-45; L. Brubaker, *Vision and Meaning in ninth-century Byzantium: image as exegesis in the Homilies of Gregory of Nazianzus in Paris* (Cambridge, 1999), esp. 19-58.

On **Catholic ideas about images**, see Chazelle, 'Pictures, books and the illiterate' (as in Chapter 5); J. Hamburger, 'A Liber Precum in Sélestat and the development of the illustrated prayer book in Germany', *Art Bulletin* 73 (1991), 209-36; and T. Noble, *Images, Iconoclasm, and the Carolingians* (Philadelphia PA, 2009). For **Gibbon**'s anti-clerical and misogynist approach, see his *Decline and Fall* (as above); on Gibbon and Byzantine iconoclasm, see L. Brubaker, 'Image, audience, and place: interaction and reproduction', in R. Ousterhout and L. Brubaker (eds), *The Sacred Image East and West* (Urbana IL, 1995), 204-20.

On **women and the Byzantine church**, see J. Herrin, '"Femina Byzantina": the Council of Trullo on women', *Dumbarton Oaks Papers* 46 (1992), 97-105 and R. Taft, 'Women at church in Byzantium: where, when - and why?', *Dumbarton Oaks Papers* 52 (1998), 27-87.

On **women and icons**, see R. Cormack, 'Women and icons, and women in icons', in L. James (ed.), *Women, Men and Eunuchs: gender in Byzantium* (London, 1997), 24-51; J. Herrin, 'Women and the faith in icons in early Christianity', in R. Samuel and G. Stedman Jones (eds), *Culture, Ideology and Politics: essays for Eric Hobsbaum* (London, 1982), 56-83; and A. Kazhdan and A.-M. Talbot, 'Women and iconoclasm', *Byzantinische Zeitschrift* 84/5 (1991/2), 391-408, who also discuss **Theodore's letters** in detail. Note the letter to Theodosia, widow of Leo V (813-820), praising the empress for her rejection of iconoclasm (epistle 538 in Fatouros, as in Chapter 4). Theodosia had, of course, been raised during the period between the two iconoclasms, and so presumably had been taught to venerate images as a child. As we saw in Chapter 6, it was only in 815 that Leo V reinstated the ban on icons. For **icon processions** involving both women and men, see Nesbitt and Wiita, 'A confraternity of the Comnenian era' (as above).

On **Photios' family and its connections with the pro-image faction**

see C. Mango, 'The liquidation of iconoclasm and the patriarch Photius', in Bryer and Herrin (eds), *Iconoclasm* (as in Chapter 6), 133-40.

There is a massive bibliography on **gender in Byzantium**, but for specific comments on **gender and rhetoric** that apply to the material discussed here see my 'Sex, lies and textuality: the *Secret History* of Prokopios and the rhetoric of gender in sixth-century Byzantium', in L Brubaker and J. Smith, *Gender in Society, 300-900* (Cambridge, 2004), 83-101.

On the **Byzantine invention of iconoclasm**, see Brubaker and Haldon, *Byzantium in the Iconoclast Era: a history* (as in Chapter 1), ch. 12.

For the **terminology of iconoclasm**, see Bremmer, 'Iconoclast, iconoclastic, and iconoclasm' (as in Chapter 1).

On the **Khludov Psalter**, see especially K. Corrigan, *Visual Polemics in the Ninth-century Byzantine Psalters* (Cambridge, 1992), on this image 30-1.

On **other iconoclasms**, see D. Freedberg, 'The structure of Byzantine and European Iconoclasm', in Bryer and Herrin (eds), *Iconoclasm* (as in Chapter 6), 165-77; L. Brubaker, 'Representation *c.* 800: Arab, Byzantine, Carolingian', *Transactions of the Royal Historical Society*, ser. 6, 19 (2009), 37-55.

On the **relationship between materiality and the cult of relics**, see P. Cox Miller, *The Corporeal Imagination: signifying the holy in late antique Christianity* (Philadelphia PA, 2009).

Index

The terms 'icon', 'iconoclasm', 'iconoclast', 'iconophile' and 'iconomachy' are not indexed due to their frequency in the text. Acknowledgements, Reference and Bibliography sections are not indexed.

Places within cities are listed as sub-headings of their urban location, e.g. for Hagia Sophia see 'Constantinople – Hagia Sophia'. Authored texts are listed as sub-headings of their author, e.g. for *Questions* (*Peuseis*) see 'Constantine V, emperor – *Questions* (*Peuseis*)'.

Page numbers in *italic* denote a relevant figure or caption, and may replicate a page number, where a particular subject occurs in the text and in a figure (or its caption) on the same page.

Some cross references are provided e.g. '*Liber Pontificalis* – see *Book of the Popes*'. Alternative terms for the same subject/theme are also provided in brackets where appropriate e.g. 'Idols (also, idolatry)'.

Aachen 62
'Abbasid – see Caliphate
Abgar, king *12*
Abydos 80
acheiropoietos (also, image not-made-by-human-hands) 11, 15, 18
Acts of John 13
Adamnán, saint 14
Adelchis, *patrikios* (patrician), son of Desiderius 58-9
Aëtios 81
Against the Synod (also *Capitulare contra synodum*) 63
Akathistos 15
Alexandria 2
al-Mamūn, caliph 92-3, 100
Alsos, Mount 101
Anastasios, patriarch 28, 33
Anastasios of Sinai
 Diēgēmata stēriktika 111
 Guidebook (*Hodegos*) 13
 Questions and Answers 17

Anatolia 15, 16, 45
Anatolikon 25, 82
Anna, wife of Leo the *patrikios* (patrician) 101-2
Annunciation 25, 38, 73-4, *73*
Anthusa, abbess 41-2
Anthusa, daughter of Constantine V 42
Antioch 2
Aphousia 101
Arab 15, 99
 conquests 2, 14, 16, 18, 70
 frontier 45, 59, 82
 raids and attacks 24-5, 27
Arculf 14
Armenia 15
Artabasdos, general 25, 32
Artemios, saint, *Miracles of* 10
Auzépy, Marie-France 48
Avars 11, 15

Baghdad 45, 93-94, 99
Balkans 1, 15, 45, 82

129

Index

Bamiyan, statues of Buddha xv
Barber, Charles 112
Bardas, uncle of Michael III 107
Basil I, emperor 39, 122
Basil of Caesarea, saint 68
Berbers 45
Bithynia 25
Bonos, *patrikios* (patrician) 15
Book of Ceremonies 96-7
Book of king Charles (also *Opus Caroli Regis*, or *Libri Carolini*) 63
Book of the Popes (also *Liber Pontificalis*) 27-8, 50, 58, 73, 75, 121
Bremmer, Jan 4
Brown, Peter 10
Bulgars (also, Bulgaria) 25, 45, 58-9, 82, 90

Calabria 46
Caliphate (also, caliphs) 16, 45, 76-7, 82, 93, 100
Cappadocia 92
Chariton, saint 70
Charlemagne, emperor 47, 58-9, 62-3, 80, 82
China 72
Christ 4, 11, *12*, 13, 17-19, 27, 32-4, 38, 61, 65, 70, 72, 74, 91, 96-7, 109-10, 120, 122-5, *123*
Cilicia 97
Classe, port of Ravenna
 Monastery of Sant Apollinare 58, 74
Claudius, bishop of Turin 4
Constantine I (the Great), emperor 2, 13, 34, 49, 59
 Donation of 59
Constantine V, emperor 5, 24, 28-9, 32-42, 45-50, 56-8, *56-7*, 60, 62, 64-6, 77, *77*, *79*, 82, 90-2, 94, 102, 109, 121
 Questions (*Peuseis*) 32-3, 49
Constantine VI, emperor 5, 49, 56-66, *57*, *65*, 77-82, *77*, 92

Constantine of Nakoleia 22-4, 113
Constantine, patriarch 48
Constantine, son of Leo V – see Smbat
Constantinople (now Istanbul) 2, 6, 14-17, 23-5, 28, 32-4, 39, 42, 47, 49-50, 58-62, 66, 70, 80, 94, 100-1
 Blachernai palace 38, 108, 116
 Bryas palace 93-4
 Chalke gate 27-9, 119-20, 122
 Chalkoprateia, church of the Virgin of the 38
 Church of John the Baptist in Phoberou 122
 Church of the Virgin of the Source 65, 73
 Eleutherios palace 78
 Golden Horn 94
 Hagia Eirene (also, the Church of Holy Peace) 5, 39-42, *40*, 65
 Hagia Sophia (also, The Great Church, the Church of Holy Wisdom) 2, 5, 25, 34-5, *36*, 41, 64, 66, 81, 94-8, 122; 'Beautiful door' *95*, 95-7; Portico of the Holy Well 96-7
 hippodrome 48
 Hodegon chapel 41
 land walls 24, 39, 94
 Milion 38-9
 Monastery of St John the Baptist of Stoudios 68, *69*, 69, 79, 81-2
 Monastery of St Panteleimon 100
 palace 24, 27, 93, 100; *Trikonchos* 99; *Sigma* 99; *Chrysotriklinos* 99-100; *Pentapyrgion* 100
 patriarchal palace 41
 sekreton 35, *36*, 64
Continuator of Theophanes
 Chronicle 98-9, 108, 121-2
Councils (also, synods)
 Constantinople III (sixth ecumenical, 680-1) 38-9
 Constantinople, Quinisext (in Trullo,

Index

691/2) 14, 17, 18, 35, 110, 111, 112, 120
Constantinople (attempted council, 786) 69
Constantinople (council 815) 91
Constantinople (synod 842-3, see also 'Triumph of Orthodoxy') 107, 108, 115, 116, 118
Frankfurt, synod of (794) 63
Gentilly, synod at (767) 47
Hiereia (iconoclast synod, 754) 5, 33-5, 39, 46-7, 50, 63, 91; *Horos* 33, 34, 38, 35, 49, 61, 63
Nikaia II (seventh ecumenical, 787) 3, 5, 49, 59, 60, 61, 62, 63, 64, 65, 66, 92, 110, 115, 118; Acts 60, 61, 62, 77, 108
Crete 92
cross 5, 17, 24, 34-6, *36*, 41, 80, 124
crucifixion 70, 72, 116, 123-4, *123*
Cyprus 70

Dalmatia 33
Damascus 45, 70, 111
Danube 15
Demetrios, saint 111-12, 117
dendrochronology 39, 67
Desiderius, king 47, 58
Diocletian, emperor 1

earthquake 24, 32, 39, 65
Edessa, mandylion of 11, *12*
Egypt 1, 15-16, 70
Eirene, empress 5, 57-68, *65*, 73, 77-82, *77*, *79*, *80*, 90, 92, 118-19
Eirene, saint 71-2, *71*
Elias, priest 38
encaustic 3
English Reformation xv, 125
Enlightenment 118
Ephesos 25
Epiphanios Hagiopolites 70
Eucharist 32-4, 91-2

Euphrates 16
Euphrosyne, mother of Theophilos 100
Eustathios, martyr 101

Francia (also, Franks) 45-6, 62-3, 100
French Revolution xv, 4, 120, 125

Gastria, monastery of 100
Gaza 70
George, confessor 14
George, saint 22, 117
Germanos, patriarch 22-5, 29, 109
Gibbon, Edward 4, 118
Gisela, daughter of Pippin 46
graptoi (Theodore and Theophanes) 92
Greece 1, 64
Greek fire 25, *26*
Gregory I (the Great), pope 63, 118
Gregory II, pope 28
Gregory III, pope 28
Gregory of Nyssa 10

Hadrian I, pope 58-63
Haldon, John 18
Hārūn al-Rashīd, caliph 81-2
Hellas 33
Herakleios, emperor 15, 25
heresy (also heretic, heretical) 3, 13, 39, 61, 98, 115
Hieron 80

iconostasis 116
idol (also, idolatry) 22-4, 49, 91
Ignatios, son of Michael I 93, 101
Ignatios the Deacon 93
Ignatios, patriarch 120
Illyricum 62
Ioannikios, saint 101
Irenaeus 13
Isaurian dynasty 25, 48, 58, 77, 102, 121
Islam (also, Muslims) 2, 15, 16, 23, 24, 34, 73, 76, 97, 111, 124, 125
Istanbul – see Constantinople

131

Index

Italy 28, 33, 46, 58

Jerusalem 2, 16, 70
 Sabas monastery 71
John, bishop of Synada 23
John, *spatharios* 111
John Chrysostom 70
John of Phenek 16
John the Baptist 69, 70
John the Evangelist 13
John the Grammarian 93-4, 96, 98, 108
Joseph, archbishop of Thessaloniki 82
Judaism (also, Jews) 23-4
Justinian I, emperor 26
Justinian II, emperor 4, 18-19, 25

Kamoulianai 11, 15
Kassia, poet 101
Katesia
 Church of St Michael 101
Khludov Psalter 122-4, *123*
Kosmas, saint 71

Lachanodrakon, Michael 48-9
Lazaros the painter 121-2
Leo, brother of Aëtios 81
Leo III, emperor xv, 24-9, 32, 48, 56,
 56, 57, 62, 77, *77, 79,* 90, 94, 120-1
 Ekloge ton nomon (also *Ekloge*) 26-7, 98
Leo IV, emperor 5, 46, 49, 56-9, *56, 57,*
 77, *77, 79*
Leo V, emperor 5, 80, 90-2, *91,* 102
Leo III, pope 80, 82
Leo the Armenian 82
Leo the Grammarian 100
Leontios of Damascus 70
Lesbos 81
Liber Pontificalis – see *Book of the Popes*
Libya 1
liturgy 35, 115-16
Liutprand of Cremona 100
Lombards 46, 58, 62
Louis the Pious, emperor 92

Luke, saint and evangelist 41

Magdalino, Paul 49
majuscule 69-70
Makarios of Pelekete, *Life* 101
Makedonia 90
Makedonian dynasty 121
Mantineon (in Paphlagonia) 41-2
Maria of Amnia 62, 78
Marmara, Sea of 65, 67, 101-2
Mary – see Virgin
Maslama, general 25
Melissenos, Theodotos 90-1
Memphis (Egypt) 11
Merkourios, saint 71
Methodios 93, 102, 107-8
 Life 107
Michael, archangel 94
Michael I Rangabe, emperor 5, 81-2, 93
Michael II, emperor 5, *26,* 80, 90-2
Michael III, emperor 5, 95-6, 107, 121-2
minuscule 69
Mohammed 15, 124
Moichian controversy 78, 81
monks (also, monasticism) 29, 47-9, 60,
 68-9, 93, 100-1, 118, 122
Moses 70
Mousele, Alexios 100

Nativity 70, 72, 73, *74,* 74, 116
Negev 70
Nessana 70
New Testament 124
Nicholas, saint 70
Nicholas I, pope 121
Nicholas of the Sabas monastery 70-2, *71*
Nikaia 93
 Koimesis church 35, *37,* 38
Nikephoros I, emperor 5, 81-2
Nikephoros, patriarch 32, 38, 41, 81-2,
 90-3, 109
 Antirresis 91
Niketas of Medikion, *Life* 98

132

Index

Niketas, patriarch 35, 41
Niketas, *patrikios* (patrician) 101-2
Ninfa and Norma, near Rome 58

Old Testament (including references to individual books) 3, 22, 27-8, 63, 65, 124
Olympos, Mount 67-8
 Symbola monastery 68
Orthodox Christianity (also, Orthodoxy) 2, 5, 9, 10, 17, 60-1, 63, 66, 108-9, 112, 115-16, 120, 125

Palermo 92
Palestine 15-16, 70
palladion 13
papacy 45, 63
Paschal Chronicle 13
Patria 66
Paul, saint 70, 101
Paul I, pope 46-7
Persia 11, 15-16, 75
Peter, saint 70, 101
plague 32
Plato of Sakkoudion 68, 78-9, 82
Philippikos, emperor 39
Photios, patriarch 109, 120, 122
Phrygia 22
Pippin, king 46, 100
Pliska 82
Princes' Islands 82
 Plate 101
 Prinkipo 65, 81
 Terebinthos 101
 Yatros 101
proskynesis 23, 61
pseudo-Symeon 57-8
Ptolemy
 Vat. gr. 1291 (also Vatican Ptolemy) 42-4, *43*
purity (also, purification) 17-18, 27, 34

Qu'ran 76, 124

relics 10-11, 14, 18, 34, 115, 125
Rome 2, 28, 46-7, 58-60, 74, 121
 Lateran, synod at 47
 palladion 13
Rothrud, daughter of Charlemagne 62

saints 4, 10-11, 13, 18, 22-3, 33-4, 49, 63, 108, 110, 112, 115, 117, 125
Sakkoudion monastery 68, 78
Ščepkina, M.B. 122
Sergios, patriarch 15
Sicily 28, 46, 58, 92
silk 66, 72-7, *73, 74, 75, 76*
Sinai, Mt 70-2
 St Catherine's monastery 70-2
Skylitzes, John
 Chronicle 26, 38
Smbat (renamed Constantine), son of Leo V 90, *91*
Spain 72
Staurakios, emperor 82
Stephen II, pope 50
Stephen III, pope 47
Stephen of Bostra 13
Stephen the Deacon 28
Stephen the Sabaite, *Life* 70
Stephen the Younger, saint 42, 47
 Life 28-9, 38, 48, 58, 119
Symeon of Lesbos, *Life* 101
Synaxarion of Constantinople 121-2
Synods – see Councils
Syria 15-16, 45

Taliban xv, 125
Tarasios, patriarch 38, 60, 63, 66, 68, 78-9, 81, 92-3
Tauros Mountains 25
taxation (also, taxes) 16, 28, 80, 100
Telerig, khan 59
tempera 3
Theodora, empress 5, 96, 100, 107-8, 118-19, 122
 Life 107

Index

Theodore, saint 10, 111
Theodore of Stoudios 32, 48, 68-9, 78-9, 80-2, 92, 100-1, 109, 111-12, 118-19
 Life 68
Theodosios, archbishop of Ephesos 33
Theodosios III, emperor 25
Theodosios, saint 70
Theodote, wife of Constantine VI 78, 81
Theodulf of Orléans 63
Theoktistos, eunuch 107-8
Theophanes, confessor 68, 81
 Chronicle 28-9, 48-9, 57-8, 66, 80, 90
Theophilos, bishop of Thessaloniki 64
Theophilos, emperor 5, 36, 76, 90, 92-102, 107-8, 121-2
Theosteriktos, monk 98
Thera 27
Thessaloniki 6, 78
 Hagios Demetrios 39
 Hagia Eirene (also, Church of Holy Peace) 5
 Hagia Sophia (also, Church of Holy Wisdom) 64-5, *65*

Thomas of Klaudioupolis 22-4, 113
Thomas the Slav *26*, 92
Thrace 25, 45, 90
Thrakesion 48
Tigris 16
Trigleia monastery 67
Trilye (Zeytinbağı) *67*, 67
Trinity 9, 34, 63, 76
Triumph of Orthodoxy (843) 5-7, 49, 107, 109, 120
Turin, shroud of 11

Ubayya, wife of governor of Nessana 70
Umayyad – see Caliphate

Venice 46
Virgin (also, *meter theou,* Theotokos) 4, 9-10, 15, 22, 33-6, 38, 41, 49, 65, 70, 94, 101, 110, 116, 125

women 28-9, 58, 63, 101, 117-19

Zacharias, pope 46, 58
Zouloupas 101

Printed in Great Britain
by Amazon